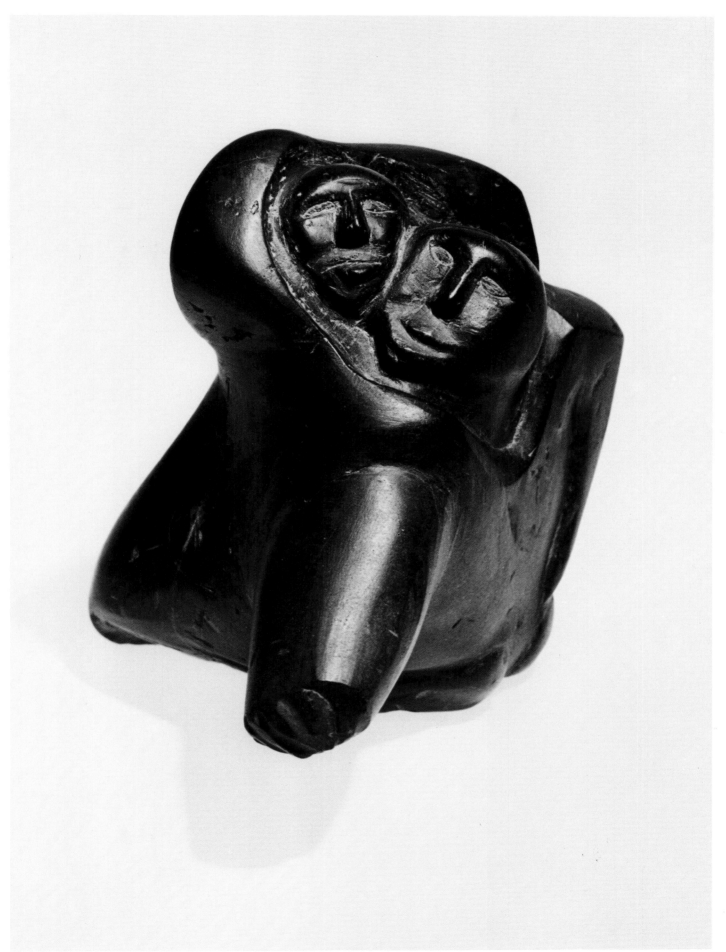

49. SILAS QIYUK, *Mother and Child,* 1974

ACKNOWLEDGEMENTS

The presentation of this exhibition has been made possible through the cooperation and support of the following individuals and institutions:

Katherine Pettipas and Maurice Mann of the Manitoba Museum of Man and Nature; Shirlee Smith of the Hudson Bay Company Archives; Jim Burant of the Public Archives of Canada; Dr. J. Hildes, Northern Medical Unit, University of Manitoba; and Frederica Knight, Winnipeg.

Elise Kutikutuk, Elizabeth and George Qulaut; Zipporah Piunngituq Inuksuk; Susan Avingaq; Andy, Rebecca and Sheba Awa; Rose Igaliyuk; Elise and Joe Attagutaluk; Jobie Inooya; Elijah Kunuk; and Paul Angilirq of Igloolik, N.W.T.

Annie Napayok; Melanie Tabvatah; Martha Ikahik; Charlotte St. John; and Lorraine Falcioni of Eskimo Point, N.W.T.

Most Reverend O. Robidoux, O.M.I., Bishop of Churchill — Hudson Bay, Father Van de Velde, O.M.I., and the late Father Ducharme, O.M.I., Hudson Bay Diocese; Lorraine Brandson and Brother Jacques Volant, O.M.I., Curator of the Eskimo Museum, Churchill , Manitoba.

Angus Kerr, Northern Social Research Division, Department of Indian and Northern Affairs, Ottawa.

Dr. David Zimmerly, John Baker, and Judy Hall, Ethnological Service, The National Museum of Man, Ottawa.

Professors Sidney Wise, Davidson Dunton, Mary-Louise Funke Campbell, and Mrs. Lois Gonyer of the Institute of Canadian Studies; Professors Graham Rowley and Derek Smith, Department of Anthropology; Professor Jean-Paul Paillet, Department of Linguistics and Modern Languages, Carleton University, Ottawa.

Sylvie Pharand, formerly of the Association Inuksiutiit Katimajiit, Université Laval, whose study "Clothing of the Iglulingmiut" (1975) provided a foundation for subsequent research.

I am most grateful to Professor George Swinton, whose generosity in sharing his ideas, knowledge, and experience, over a number of years, has helped to bring this exhibit to fruition. Special thanks are also due to Jean Blodgett, the Gallery's former Curator of Eskimo Art, whose past exhibitions and catalogues have been a tremendous aid in preparing for the current exhibition.

The Winnipeg Art Gallery gratefully acknowledges the generous assistance of the Canada Council.

Bernadette Driscoll
Associate Curator
Inuit Art

TABLE OF CONTENTS

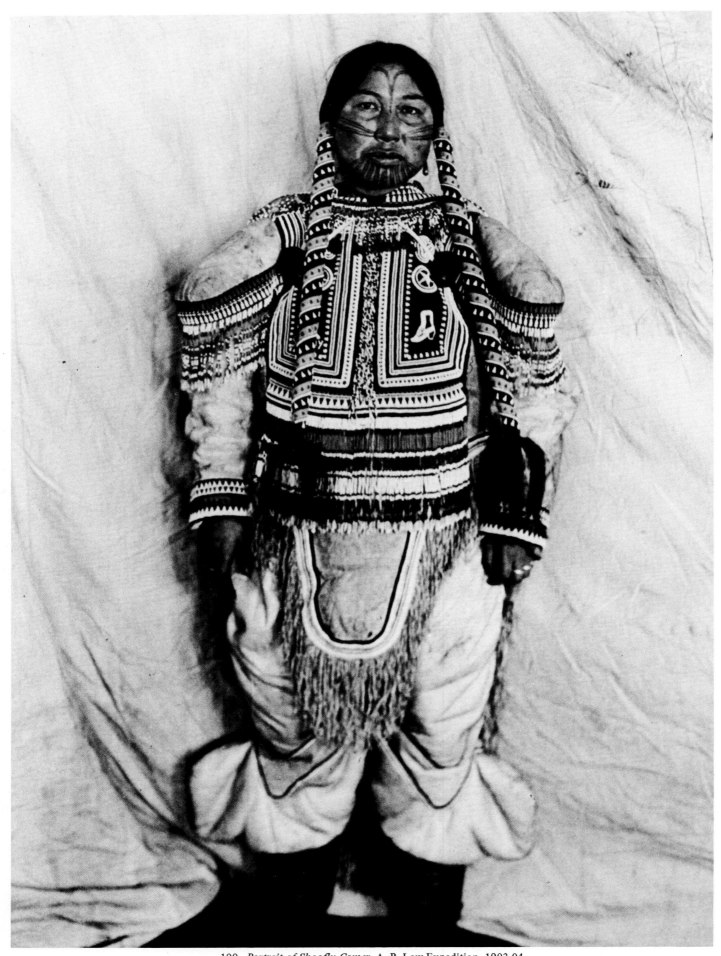

100. *Portrait of Shoofly Comer,* A. P. Low Expedition, 1903-04

INTRODUCTION

The depiction of mother and child is a popular and recurrent subject among Inuit artists. Although addressing the theme of maternity, the current exhibition is basically concerned with the artist's rendering of the *amautik,* the traditional parka of the Inuit woman.

The *amautik* takes its name from the *inuttitut** phrase meaning "to carry", and refers to the pouch or *amaut* incorporated in the back of the woman's parka which is itself designed to carry a baby. The *amautik* was traditionally worn by every Inuit woman regardless of marital or maternal status. In adopting the *amautik,* or "mother's parka", a young woman took on the symbol of her fundamental responsibility within Inuit society: to provide for the regeneration of human life.

To show the design of the *amautik* and its evolution throughout a woman's life, four caribou *amautiit* from the Bishop Marsh Collection of the Manitoba Museum of Man and Nature and one from the private collection of Mr. and Mrs. K. J. Butler are included in the exhibition. This collaboration of historical artifact and contemporary works of art offers a rich opportunity to explore the *amautik* as a unique and essential element of Inuit culture.

Note: **inuttitut* is the term for the Inuit language. The meaning of a word in *inuttitut* is modified by changing the suffix or adding infixes to the root.
For example:
amaq: to carry
amaut: carrying pouch
amautik: parka with carrying pouch
 (*amautiit:* plural)
amariik: mother carrying child in the *amautik.*

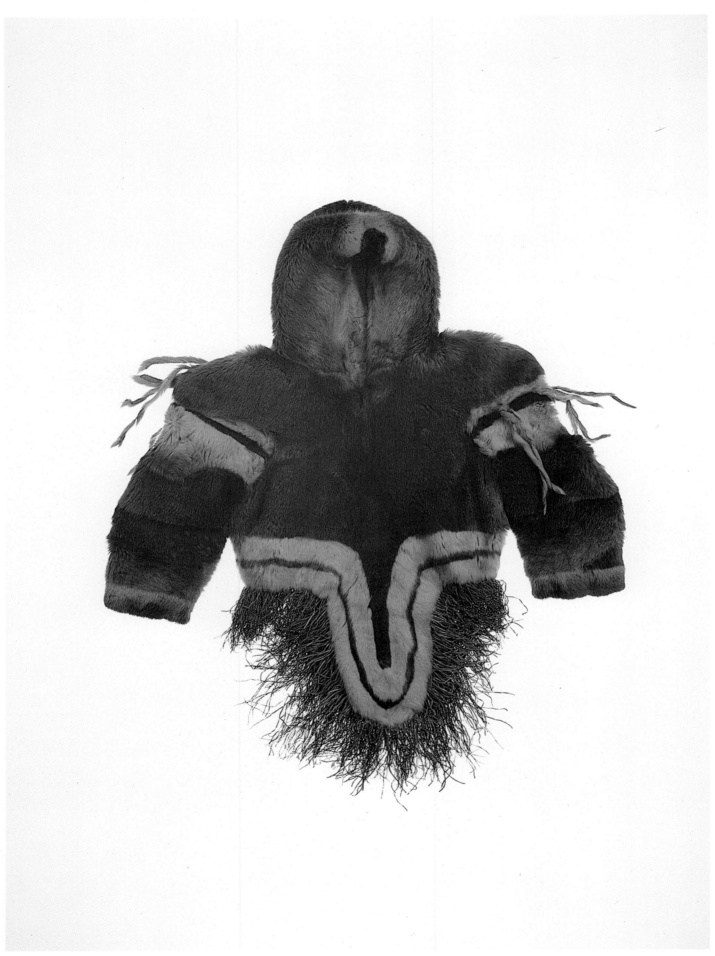

1. Child's *Qulittaq*, Eskimo Point, c. 1938

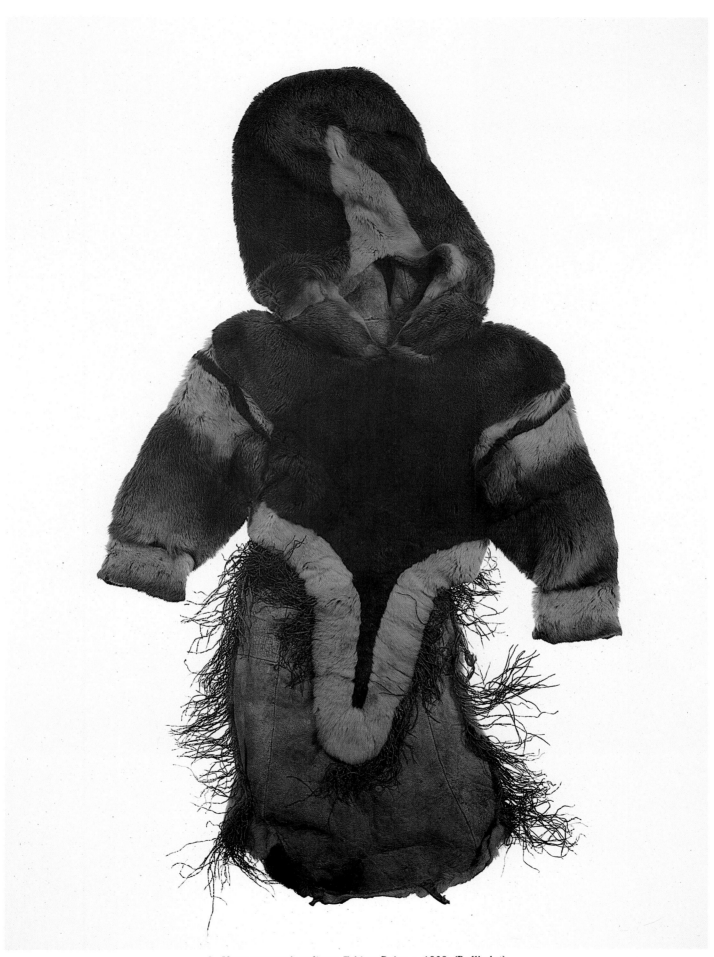

2. Young woman's *qulittaq,* Eskimo Point, c. 1938, (Padlimiut)

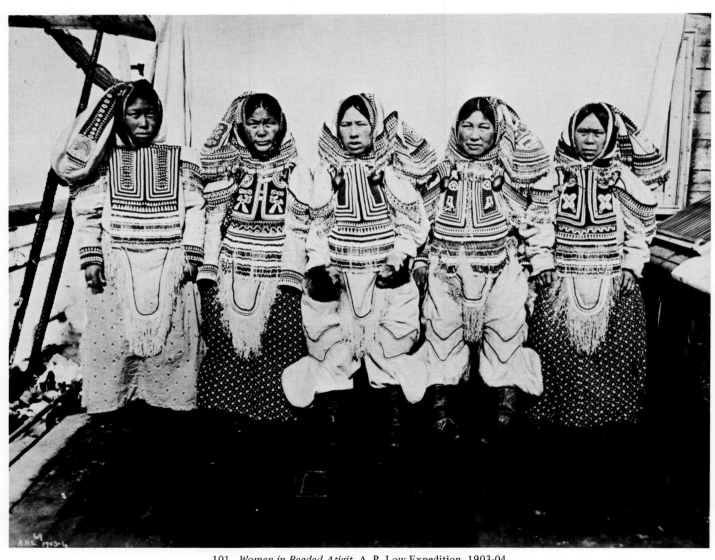

101. *Women in Beaded Atigit,* A. P. Low Expedition, 1903-04

THE AMAUTIK IN INUIT HISTORY AND CULTURE

The Inuit Parka

The Inuit parka is ideally suited to the severe climate of the Canadian Arctic. The parka, a fur jacket with attached hood, is worn in two layers: an inner layer (*atigi*) in which the fur lies directly against the wearer's body and an outer layer (*qulittaq*) in which the fur faces outward. The layer of air trapped between the two fur layers acts as insulation for the wearer. As well, the bulky design of the parka permits a free circulation of warm air around the wearer's body.

The principal skins used for the Inuit parka are those of the caribou and seal. Of all Arctic animals, the caribou provides the fur with the greatest protection against the harsh climate of the North. Each hair of the fur is hollow and fills with air, increasing the heat-retaining quality of the fur. As long as caribou is available, it is used, especially for winter clothing. In summer months, inland Inuit shed the outer parka and wear only the *atigi*. Coastal groups, however, prefer to wear sealskin parkas through the late spring and summer; the sealskin is water-repellent and therefore of particular benefit to the hunter when sealing or hunting from the kayak in open water.

Although the treatments of caribou and sealskin do not differ substantially, there is a marked difference in the final result. Both skins are laid out in the open air to dry. When the caribou skin has dried, the surface layer of blood and excess fat is removed by scraping. The skin is then moistened and rolled. To soften it further, it is often sat upon or used as a mattress. In its final treatment, the skin is scraped vigorously with a sharp instrument to remove the coarse epidermal layer. The hide becomes extremely supple, revealing a finish of soft white suede.

Caribou skin is usually left with the fur intact and only the choicest skins are selected for clothing. Of the caribou skins chosen, those with a thicker fur are used for the *qulittaq*, while the finer, softer furs are worn as the under garment or *atigi*.

Sealskin may be used with or without its fur. If the skin is to be used for a parka, the fur is reserved; if the skin is needed for waterproof boots or mitts, the fur is shaved off. The impermeability of the skin makes it a desirable parka material during the spring and summer. However, as a 19th century ethnologist observed: "no amount of working will render [sealskin] more than moderately pliable."[1] Therefore, although sealskin is used for both men's and women's parkas in Greenland, Baffin Island and Labrador, it is reserved for men's parkas in the Central Arctic[2] and is seldom used in the Western Arctic.[3]

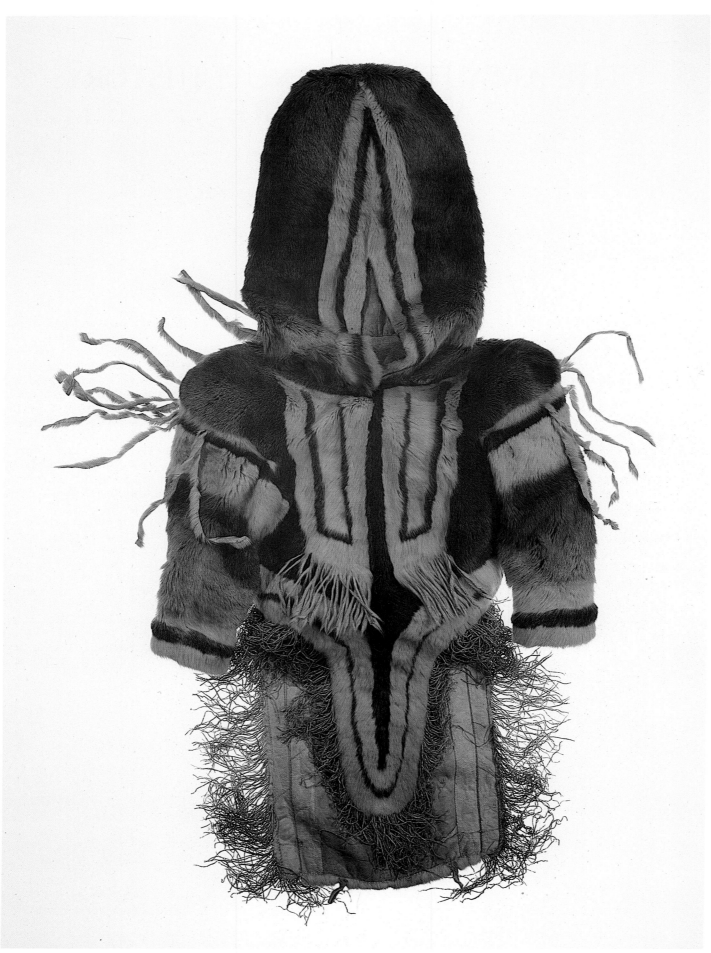

3. Young woman's *qulittaq*, location unknown, c. 1938

102. MARTHA IKAHIK, *Figures in Beaded Parkas,* 1978

13

HUNTING PARKA VS. AMAUTIK

Although both men and women wear the parka, the form of the parka differs according to the role of each sex in Inuit society. The man's parka is closer fitting and more economic in its pattern than the *amautik.* To cut down on the number of seams, which act as tiny openings through which the wind can enter, only large pieces of fur are used in the construction of the man's hunting parka.

There are no lateral openings in the front or back, for the parka is pulled on over the head. In length, the man's parka falls to the thighs and is slit on each side. The most traditional men's parkas are designed with a long rectangular panel hanging down the back which is known as an *akuq* or "tail". In the late 19th century — perhaps due to outside contact — this tail was cut shorter and now hangs only slightly longer than the front flap of the parka.[4]

In designing the hunting parka, it was the custom to retain certain features of the caribou, such as the ears, as a metaphoric and symbolic reference to the animal.[5] In the Copper parka the resemblance between hunter and animal was dramatic and no doubt intentional. Diamond Jenness writes:

> It was customary to peak the hood of the coat, and this peaking, with the two upstanding ears and the long tail trailing between the legs, gave a stooping Eskimo so close a likeness to a caribou that it sometimes deceived his dogs hauling on the sled behind him and spurred them on to greater effort.[6]

In contrast to the hunting parka, the design of the *amautik* focuses on the maternal role of the woman. From northwestern Alaska to Greenland, the form of the *amautik,* or "mother's parka" remains unchanged. It incorporates a large hood (*nasaq*), a roomy back pouch in which a woman may carry her baby (*amaut*), a back tail (*akuq*), and a front "apron" (*kiniq*). The broad shoulders of the *amautik* allow a child to be brought from the back of the parka to the front for nursing, merely by a twist of the shoulder. The large hood, when worn over the mother's head, allows fresh air to filter down to the child riding in the *amaut*. Larger panels of material can be sewn into the *amaut* to accommodate the child as he/she grows. In this way, the *amaut* can be seen as a symbolic reference to the womb — which itself enlarges as the fetus develops. A child can be carried in the *amaut* from infancy until the age of two or three.

In addition to the *amaut*, the *kiniq* is a distinctive and characteristic feature of the woman's parka. The *kiniq,* or front flap of the *amautik,* falls like an apron in front of the woman's body. This appendage, common to all women's parkas across the Arctic, has puzzled *qablunaat* observers since the days of the early explorers. The most widely accepted explanation of the *kiniq* is that it has developed as a convenient "apron" upon which to lay a baby.[7]

Linguistically, the term *kiniq* has a number of interesting associations. As explained earlier, *inuttitut* is agglutinative in its formation: terms are modified, or new terms are created, by adding suffixes or in-

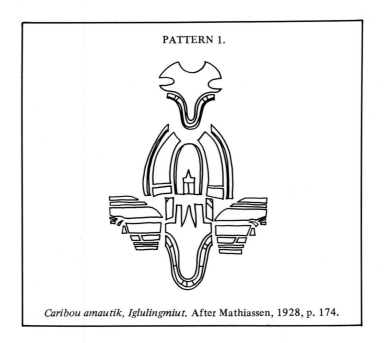

PATTERN 1.

Caribou amautik, Iglulingmiut. After Mathiassen, 1928, p. 174.

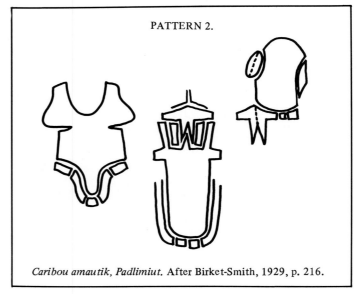

PATTERN 2.

Caribou amautik, Padlimiut. After Birket-Smith, 1929, p. 216.

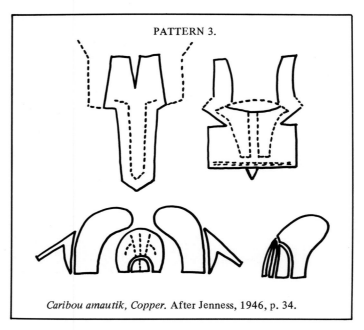

PATTERN 3.

Caribou amautik, Copper. After Jenness, 1946, p. 34.

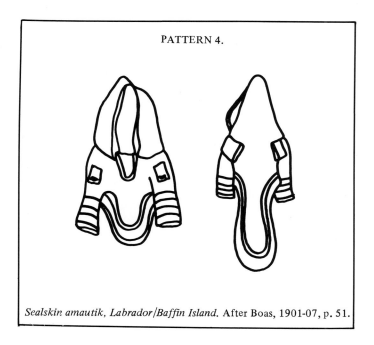

PATTERN 4.

Sealskin amautik, Labrador/Baffin Island. After Boas, 1901-07, p. 51.

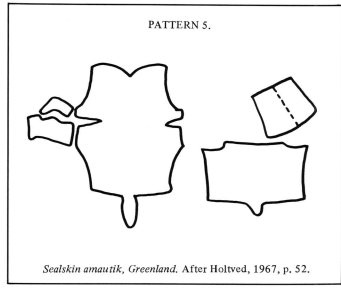

PATTERN 5.

Sealskin amautik, Greenland. After Holtved, 1967, p. 52.

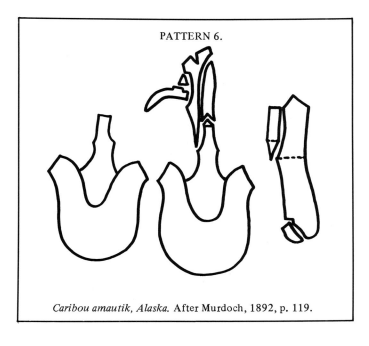

PATTERN 6.

Caribou amautik, Alaska. After Murdoch, 1892, p. 119.

fixes to the root. Therefore, groups of words having the same root are often related in concept or source. Words which may be related to the term *kiniq* include:

kinerservik: the snowhut or tent in which a woman gives birth.[8]
kinersertoq: a woman occupying the birthhouse.[9]
kiniyoq: a colloquial term used only with young children to ask if they wish to urinate.[10]
kiniva, kiniyiyoq: elle (il) le fait uriner (le bébé); (de kineq vraisemblablement: le tenant devant son kineq?)[11]

This association of the term *kiniq* with childbirth, as well as the urinary function (and organ), suggests the relationship of the *kiniq* itself to conception and birth. Although the shape and dimensions of the *kiniq* vary across the Arctic, the appendage is found consistently on the parka of the Inuit woman, and only rarely on the parka of the man. The *kiniq*, in combination with the *amaut*, makes the *amautik* a uroboric symbol: a symbol of both the conception and regeneration of human life.[12]

II. THE AMAUTIK: REGIONAL VARIATIONS IN STYLE

Across the Arctic, the form of the *amautik* remains the same. However, variations in resources and environmental factors — as well as design skill and local taste — have encouraged the evolution of distinct regional styles in *amautik* design. By the cut and appearance of the *amautik*, the region and locale from which a person comes is immediately known. Patterns 1 through 6 show patterns of *amautik* design from selected locations across the Canadian Arctic, as well as Greenland and Alaska.

Patterns 1 and 2 illustrate the *amautik* pattern for two Inuit groups in the Central Canadian Arctic: the Iglulingmiut (Pattern 1) and Padlimiut (Pattern 2)*. The front (*saa*) of each parka is cut from a single piece of caribou skin. It extends over the shoulders and is joined to the back section with a seam across the shoulder blades, thus avoiding the stress of a seam on the shoulder.[13] The *saa* covers the front of the body and ends in the scalloped *kiniq* which falls to about knee-length. The back (*tunu*) is essentially one large piece of caribou skin which ends in a tail reaching almost to the ankles. The hood is cut separately, but is anchored by a piece of skin called a "hood root" which slips into the back of the parka. The decoration of the outer parka consists of broad strips of *pukiq*, a white fur taken from the underbelly of the caribou, which contrasts sharply with the rich brown colour of the caribou fur.

Although the basic form of the Iglulingmiut *amautik* is identical to that of the Padlimiut, the cut of the pattern is distinctive. The *akuq* of the Padlimiut parka is cut almost square at the bottom with

*See MAP for the traditional geographical distribution of Inuit groups.

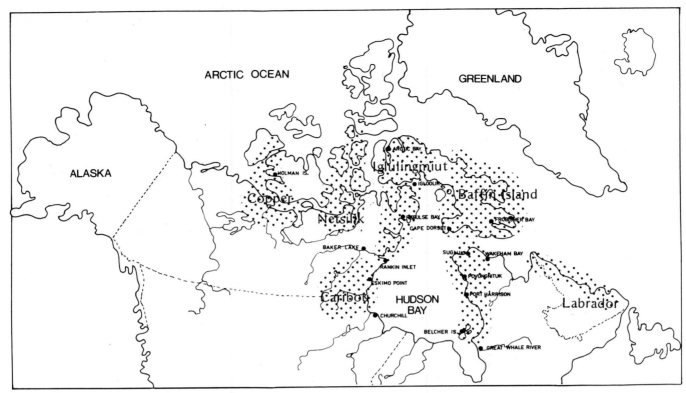

MAP. Contemporary settlement locations and historic Inuit occupations. After McGhee, 1978, p. 104.

curved edges, while the cut of the Iglulingmiut tail is more narrow and rounded. Both *amautiik* make extensive use of *pukiq* decoration, contrasting the light and dark fur of the caribou both within the garment as well as along its edges.

Pattern 3, a pattern originally recorded by Diamond Jenness in 1916, illustrates the cut of the Copper *amautik* from the vicinity of Victoria Island in the Western Arctic. The Copper *amautik* contrasts sharply with the Iglulingmiut and Padlimiut mother parkas. The *saa* is cut short reaching only to the waist. A triangular wedge or tongue-like appendage hangs from the centre front of the *saa*, a vestige of the full elaborate *kiniq* of the Central Arctic *amautik*. The *saa* is decorated with two large *pukiq* insets covering the breast area. In some Copper communities, the insets are trimmed with leather strips dyed red or black.[14] The breast insets are also found on the man's parka although these are rounded rather than angular in form. Like the Keewatin parka, the Copper *amautik* features an extended tail. However, the Copper tail is quite rectangular in its cut, while the tail of the Keewatin *amautik* is fuller and rounded. The Copper *amautik* is finely edged with narrow borders of *pukiq* around the *kiniq* and *akuq* and three thin stripes of *pukiq* are found on the wrist of each sleeve.[15]

Pattern 4 illustrates a sealskin *amautik* from the Eastern Arctic (Labrador/Baffin Island). The differences between sealskin and caribou as parka material account for the corresponding differences in the design of this parka as compared to the caribou *amautik* of the Central Arctic. In Pattern 4, the *amaut* and hood are formed from a single piece of skin. The *amaut* is a roomy pouch, the shape of which is formed by a leather belt worn around the waist.

The tail, which has a curvilinear cut, is joined to the *amaut* by a seam at waist-level. The *kiniq* is cut shorter and more rounded than either the Iglulingmiut or Padlimiut *amautik*. The sleeves, which extend in a continuous line from the hood, are marked with four dark strips of sealskin around the lower arm. Unlike the caribou parka, the sealskin parka is not fringed.[16]

The styles of *amautiit* at the extreme regions of the Arctic exhibit the greatest contrast to the Central Arctic *amautik*. In Greenland, small furs such as seal, fox, and even birdskins are used in place of caribou.[17] The parkas of both men and women are cut extremely short, reaching only slightly below the waist. The back of the parka features a tiny *akuq*, a feature by which Greenlanders are recognized in the Canadian Arctic. They are called *AKUKITTUT* or "the people with little tails."[18] Unlike that of the Central Arctic parka, the *kiniq* in Greenland is a feature common to the parkas of both sexes.[19] (Pattern 5)

In Alaska, the design of both men's and women's parkas appear more dress-like in form. In the woman's parka, the distinctive features of the *kiniq* and *akuq* have evolved into two large scalloped flaps of almost equal size. A reference to the *kiniq* is still evident, however, in that the front flap is comprised of two pieces: the inner *kiniq* and the surrounding *pukiq* decoration (see Pattern 6). It is likely that this evolution towards a dress-like design is a result of early contact with Russian and American sources.

III. EUROPEAN AND AMERICAN CONTACT

Although the basic form of the *amautik* remained the same, prolonged contact with European and North American sources introduced changes in the style of the *amautik*. In the Eastern Arctic, the influence of American whalers introduced the "new" *amautik* known as the *angijurtaujuq*.[20] Although still a mother's parka, the *angijurtaujuq* is evenly hemmed with no indication of *kiniq* or *akuq*. Therefore, it closely resembles the cut of a Western woman's dress. The style was introduced in the vicinity of the whaling stations on south Baffin Island and carried to other communities in the Eastern Arctic by Inuit women who travelled on the whaling boats.[21] It was received with the same excitement which would greet a major fashion revolution in the Western world and was quickly adopted, earning a place side by side the traditional *amautik*. The lithograph by Pudlo, entitled *The New Amautik* (**97**), shows the cut of the *angijurtaujuq*, still worn today in many settlements of the Eastern and Central Arctic.

In the Western Arctic, an equally dramatic transition in *amautik* style took place, also as a result of *qablunaat* influence. The distinctive dress of the Copper woman, which was characterized by a long back tail and short-waisted *saa*, gave way to an ankle-length dress called a *kaliku*. The distinctive feature of the *kaliku* (also known as a "Mother Hubbard") was the outer covering of store-bought calico, hence the name. The *kaliku* is itself an *amautik* but does not feature the ample back section, nor the large hood characteristic of the traditional Central or Eastern Arctic mother's parka. Instead, the hood is close fitting with a ruff of wolf fur encircling the wearer's face. The *amaut* itself is very small, almost to be overlooked. Because of the tiny *amaut*, the Mother Hubbard is not accepted by some Inuit as an authentic *amautik*. In Eskimo Point, an older woman refused to make a Mother Hubbard for a schoolteacher in the settlement. She considered the dress suitable only for young children and elderly women. It was not fitting for a woman in the prime of her child-bearing years.[22]

Although European and American contact introduced changes in the cut (though not form) of the *amautik*, the more striking change was in *amautik* decoration. Traditionally, parka "decoration" consisted of amulets, which in a magical way, either enhanced a person's skills or offered protection against physical and spiritual harm. Amulets were seen as ". . . helping spirits of a kind that people wore on their person."[23] The decoration was not simply ornamental but made spiritual protection portable:

> . . . it is the spirit of the object, the spirit of the owl, the swan, the ptarmigan, that comes to one's aid when that which symbolizes it is worn on the body.[24]

As a rule, the *amautik* was richly endowed with these spiritual helpers. A woman wore amulets not only for her own protection but also for the protection of her sons, born or unborn. Even young girls wore amulets for their future sons, which they eventually turned over to their offspring. This was considered important "for the older an amulet is, the more powerful it is."[25] The benefits which accrued to the son depended on the specific amulet worn by the woman. For instance, the tail bones of a seal made a son lucky while sealing; a gull's foot made him a good salmon fisher; caribou front teeth provided luck while caribou hunting; and the ears of a hare ensured the son keen hearing.[26]

Amulets were also deemed beneficial to the woman herself. She might wear amulets to ensure that her first child would be a boy or that she would have an easy delivery. It was not only the object itself, but the positioning of the object on the body that gave it its power. For example, by sewing the udder of a hare inside the *atigi* and over her breast, a woman was assured an abundant supply of milk.[27]

The influx of Western trade items supplanted the traditional use of amulets. Coins, lead shot, spoons, beads, and even metal tags from tobacco containers were adapted for parka decoration.[28] The metal objects were pierced and strung about the neck and around the outer edge of the *kiniq* and *akuq*.

In the area of south Baffin Island and Labrador, the handles of pewter spoons were broken off and the spoon bowls were hung in a vertical column on the front of the *kiniq* and sometimes down the centre back of the *akuq*.[29] The use of coins and other small metal objects was historically popular in this area because of the frequent contact with the crews of whaling ships which anchored in Hudson Straits to wait for the ice to break up in the spring.[30] The drawings by the artists Eegyvudluk and Ulayu (**78, 79, 99**) illustrate this type of decoration which is still vivid in the memories of some Cape Dorset residents.

Perhaps the most popular trade item introduced into the Canadian Arctic was the tiny seedbead. By 1821, Captain George Lyon notes that beads were already in common use by the Iglulingmiut; by the time of Lyon's departure in 1823, the crews of the *Hecla* and *Fury* had more than doubled the number of beads in the possession of the local residents. Engravings based on drawings completed by Lyon indicate that the style of beadwork practiced among the Iglulingmiut consisted simply of freehanging lengths of beads attached to the front of the parka.[31] However, by the early 1900's, the annual visits of the whaling ships to south Baffin Island and the west coast of Hudson Bay had greatly increased the availability of beads and the intricacy of beadwork design. Included in the exhibit is a photograph of five women in beaded parkas (**101**) taken on the deck of the Canadian ship, the *Neptune* (1903-1904). The hood as well as the front of each woman's *atigi* is richly decorated in beads. Although the design motifs on each parka are highly individualistic, the overall pattern or placement of beadwork on the *atigi* is strictly uniform. The beadwork motifs rendered by Shoofly (**100**) — whose name is written in white beads at the lower right side of the breast panel, but in the photograph is covered by her *tudlik* or hairstick — is representative of the whaling experience. The motifs include a ship's compass and a high-heeled woman's boot. On the back of the hood

the scene of a kneeling hunter pointing his rifle at a caribou is richly and colourfully illustrated in beads.

The introduction of beads to different regions of the Arctic varied considerably. Whereas beads had become a popular commodity in the Eastern Arctic by the mid-19th century, it was not until the early part of the 20th century that beads became readily available through the Hudson Bay outposts in the Central Arctic. The first shipment of beads to the outpost at Chesterfield Inlet records an inventory of 290 bundles in a wide variety of colours, including violet, green, scarlet, pink, turquoise, lemon, white, black, and orange.[32]

Beadwork patterns in each region took on a distinctive local style. In the Baffin area, where greater interest was paid to the 'jingling' metal ornaments, beads were strung from shoulder to shoulder to create simple horizontal colour bands across the front of the *atigi*. In the Central Arctic beadwork patterns were more elaborate; the beads were applied to a brightly coloured cloth backing and a wide variety of design motifs were used. In the area around the whaling stations on the west coast of Hudson Bay, icons of the whaling period were recreated: a teakettle, a high-heeled shoe, a compass, and even ribboned bows decorated the front panels of the *amautik*. The style inland was more floral in its appearance and suggests comparisons to the beadwork design of native Indian groups.[33]

The beadwork on the woman's parka (4) collected by Reverend Marsh in 1938, shows a somewhat different style of beadwork. The beading is still done on a cloth backing and follows the standard form of two breast panels, divided down the middle and edged along the sides. However, the design within the breast panel is freer and more pictorial (perhaps even narrative) in its imagery, than the designs known in the vicinity of the whaling stations. Within the breast panel of the parka are included four discs of white beads, two on each side. The two outside discs have centres of red beads, while the inside discs are solid white circles. Could this be a reference to the sun and moon? The moon, which gives light but not heat, would be denoted by the discs of white beads; while the sun, which gives both light and heat, would be depicted by the discs with the red centres. The placement of the four discs — sun, moon, moon, sun — might be interpreted as a reference to the change of seasons, from light to darkness.[34] The double chevron of gold and blue beads sewn in the lower inside corner of each panel, might be seen as a reference to the northern lights, with their long streams of colour crossing the dark sky.[35]

As suggested by the beadwork of this particular parka, beadwork designs were the personal invention of the individual. Beads opened up for Inuit seamstresses a novel opportunity to render shapes and images in two-dimensional form. The art/craft of the Inuit seamstress — the tradition of making parkas and especially the creative freedom offered in beadwork design — has served as a foundation for graphic expression in other media.[36]

IV. THE TRADITIONAL ROLE OF THE WOMAN

A study of the *amautik* would not be complete without a discussion of the woman's traditional role in Inuit society. Historically, the home was the centre of the woman's activity. Throughout her childhood, a girl's training focused on the development of domestic skills. In the company of her mother she learned to cook, prepare skins, and make small articles of clothing. She watched over the younger children in the family and often borrowed her mother's *amautik* to carry about a baby brother or sister. The girl's training was directed towards a single goal: to marry and raise a family. Sometimes she was promised to her future husband at birth. Such an arrangement was a comfort to her parents for it lent a measure of security to the girl's future. In times of starvation, when female infants might be killed at birth, the honour of her parents' promise ensured the child's survival.

As a girl grew older, certain changes took place in the design of her parka to signify her maturation. As a very young child, a girl would wear a parka that in its cut was similar (although not identical) to a boy's parka (77). As she grew, however, certain features of the parka "grew" as well. As can be seen in three of the caribou parkas included in the exhibition, the features which are specifically related to the maternal role become more prominent as a girl matures. Figure 1, which is the parka of a very young girl, features a close-fitting hood, short tail and a small *kiniq*. In Figure 2, the parka of a girl of perhaps eleven or twelve, the hood has become somewhat larger, the shoulders are fuller, the tail is longer and the *kiniq* is more accentuated. Figure 3 is the parka of a young woman of marriageable age and is most similar in its size and design to the adult *amautik*. The hood is quite long, the shoulders are broad, the *kiniq* is a full apron-like shape and the tail reaches almost to the ground. At the hem of the tail are two leather loops which allow the parka to be worn with the tail turned under. In Labrador, the turning under of a woman's *akuq* was the sign of her menses;[37] among the Iglulingmiut, it was the style worn by a woman until she had given birth.[38]

If arrangements for marriage had not been made by the time a girl adopted the *amautik*, the parents of a young man (or the man himself) would approach the father of the girl. With the advice of his wife, the father chose a suitable mate for his daughter. It was not unknown that a girl refused to follow her father's wishes; or worse still, refused all offers of marriage. A number of Inuit legends — or "morality tales" — are told in which such a situation occurs. The girl usually comes to a sorry end for her arrogance. In one story, she finds that the man she finally chooses to marry is actually a raven in disguise. She is horrified and after a series of episodes manages to escape. She returns to the community and marries the first man who comes to the settlement and asks for her.[39] In another story, two married women, after quarrelling with their respective husbands, decide to strike out on their own. After some time their fathers (not husbands)

come in search of them. The fathers find, to their surprise, that the women have managed to provide for themselves and have no desire to return to their former life:

> . . . having staid (sic) two nights at their daughters' house [the fathers] returned home, where they told the strange story that two women without the company of men lived all by themselves and were never in want.[40]

Such a situation was so uncommon as to become legendary. For in traditional Inuit society, husband and wife formed an economic unit. Their marriage was a partnership in which each had responsibilities to fulfill which made life possible for the other. It was the woman's responsibility to sew, but she had to depend on her husband for skins and sinew. If the woman was an outstanding seamstress and her husband a poor hunter, her skills were sorely tested. On the other hand, "miserable is the hunter who marries a poor or lazy seamstress."[41]

As important as sewing and cooking were, a woman's primary responsibility was to bear children — especially male children who could contribute to the family welfare through hunting and provide for the parents in their old age. As Rasmussen reported in the 1920's, the desire for male progeny led to a high incidence of female infanticide, especially among the Netsilingmiut. The Netsilingmiut lived an impoverished and precarious existence, dependent on a fluctuating supply of game. Only by increasing the number of hunters, could the community increase the odds of survival.

> We get old so quickly and so we must be quick and get a son . . . If my daughter Quertilik had a girl child I would strangle it at once. If I did not I think I would be a bad mother.[42]

To nurse a girl child for two or three years was a luxury most parents avoided out of necessity; they could not afford to wait that long for the next pregnancy.[43]

Despite the fewer number of females in Inuit society, there did exist instances in which a man had two wives. This was a mark of distinction, for only the most successful hunters could provide for more than one wife. Certain customs accounted for the practice of polygamy. If the first wife were unable to bear children, or had not yet provided a son, a second wife might be taken. In such a situation, each wife kept her own side of the house with the lamp and soapstone pots which she brought to the marriage and kept as her personal property. Rasmussen reports that the relationship between two women who shared the same house — and the same husband — was usually amicable. The two women addressed each other as *igloqatiga* or "my housemate".[44] Polyandry, or the practice of a woman having two or more husbands, was also an acceptable custom in traditional Inuit life. Rasmussen reports, however, that this situation "usually comes to a distasteful end" with the jealousy of one husband leading to the murder of the other.[45]

Although a woman's responsibilities were focused on family and home, she also assisted in the provision of food. Her participation was especially active in the summer months, when she helped to fish char from the rivers, collect eggs, and hunt geese (96). In the large organized caribou hunts, women (and children) played a secondary though necessary role in herding the animals toward the waiting hunters. If the animals were on land, the women and children hid behind stone figures (*inuksuit*), emerging at the proper moment to stampede the herd towards the hunters. If the herd was crossing a lake or river with the hunters in kayaks behind them, the women would hide on the opposite bank; as the first caribou reached the shore, they would race towards them shouting and scaring the animals back into the water.

More significant than her direct participation in the hunt was the woman's involvement in its symbolic or mystical aspects. In traditional times, most Inuit groups maintained a strict division between land and sea hunting. The Inuit believed that the spirit forces governing the land and sea were offended if the animals of one province were allowed to come into contact with the animals (or products) of the other. For this reason, clothing used while seal hunting could not be taken inland while hunting caribou. Instead, it had to be buried at the summer camp along the coast.[46] Similarly, the sewing of caribou skins had to be completed before moving out onto the sea ice for sealing. If the sewing was not finished at the time of the move, a separate snow house was built on the land to which the women returned each day until the work was completed. During the period of strictest taboo — that is, in the dark months of winter, when game was scarce — even the meat of land and sea animals had to be separated: caribou and seal could not be eaten on the same day.

When a seal was brought back to the village, it was the duty of the hunter's wife to placate the soul of the slain animal. It was believed that the seal had allowed itself to be caught in search of fresh water. The woman placed drops of fresh water into the seal's mouth to refresh the soul, ensuring that, reborn in the flesh of another seal, it would return again to the harpoon of her husband.[47]

The hunter's wife was also responsible for the division of her husband's catch. The meat was shared with other members of the hunting party and with needy families in the community. The wife of a successful hunter, therefore, gained prestige and authority within the group.

The woman also presided over the initiation of new hunters. The first seal caught by a young novice was cause for great celebration within the community. The mother of the boy allocated the portions of the child's catch among the community. As many people as possible were invited to share in the meal; this ensured that the boy would be a successful hunter and would always have meat to share.

The most significant influence a woman possessed over the hunt, however, was directly related to her role in the mystery of conception and birth. During menstruation a woman was considered a major threat to the hunt. She was obliged to inform the entire household of the time of her menses, and during these periods her activity was severely restricted. She was not allowed to share in the family meal but had to eat apart, preparing her food in

separate utensils reserved for the occasion.[48] She was strictly forbidden to touch the men's hunting tools or even to look in the direction of game. If a menstruating woman was unknowingly brought along on a hunt, the excursion was doomed to failure.

The strict observance of taboo was believed to be the only way to secure the goodwill of the spirit forces which controlled one's life. The plenitude or scarcity of game was an indication of the favour (or disfavour) with which a community was regarded in the "eyes" of the spirit world. The woman's mystical relationship to the hunt, and the severe restrictions periodically placed on her activity, made her an object of suspicion in times of scarce game. In that she was not herself a hunter, it was feared that through some unwitting or frivolous transgression, she was apt to jeopardize the welfare of the entire community.[49]

During pregnancy and at the time of childbirth the taboos which ordinarily governed a woman's life were intensified. She was forbidden to eat specific foods or to do certain types of work. To break a taboo not only endangered her own life but also that of her unborn child. In the special snowhut (*kinerservik*) which was built for her delivery, the woman gave birth, secluded from the rest of the community. Alone, she enacted the universal rite of womanhood: to give life and rejuvenate the human species. Thus the *amautik,* with its pouch ever ready to receive new life, becomes the perfect symbol of this elemental role of the woman.

V. THE PRESENT

Throughout this essay the emphasis has been placed on the traditional life of the Canadian Inuit, known most thoroughly through the Report of the Fifth Thule Expedition (1921-24).[50] Although historically valid, most of the customs and traditions recorded here survive only in the memory of older Inuit. The transition from hunting camps of a few families into urban settlements of 100 to more than 1000 people has radically changed Inuit culture as it was known and practiced, even as recently as the 1950's.

It is impossible to describe in any complete way the corresponding change in the role of the Inuit woman. More than ever before, the woman is faced with a range of choices with regards to her life and profession. In northern settlements, as well as in the South, women are assuming professional and administrative positions. No longer is government, teaching, broadcasting, nursing or the social services the province of *qablunaat.* In carving and print-making, where women have always been well-represented, the works of Kenojuak, Pitseolak, and Annaqtuusi (to mention only a few) have earned international recognition and respect.

This is not to ignore the traditional role of the woman as mother and homemaker. In the settlements today, it is not unusual to enter a home where the woman is sewing a parka or softening sealskin to make waterproof boots. Especially if the husband is a full-time hunter, the family may spend only part of the year in the settlement, going out on the land for long periods during the spring and summer months.

In many ways, in fact, in spite of the "choices" available to the contemporary Inuit woman, her role, life, and security have been undermined by the influx and influence of *qablunaat.* The traditional role of the woman as teacher and "preserver of the culture" has been usurped by a formalized (and southern-oriented) school system. Increasingly, the Inuit woman is forced into a more formal and outspoken position, within the home as well as outside it, to make known her concerns for the welfare of her family and community. With her role still in transition, the Inuit woman struggles to adapt to the difficult and confusing combination of old and new — and to find a place for herself within it.

Undoubtedly, Inuit life has changed radically in the last twenty or thirty years. Yet, this is precisely the period of time during which Inuit art has flourished. It is through the work of contemporary Inuit artists that we as outsiders are offered a means of seeing and understanding the traditions, values, variety and humour of Inuit life. Through sculpture, drawing, and printmaking, we are given an insignt into the past and the changing present. Pitseolak was not speaking for herself alone when she said,"I know I have had an unusual life, being born in a skin tent and living to hear on the radio that two men have landed on the moon."[51]

The current exhibition, through its consideration of the design and historical significance of the *amautik,* as well as its manifestation in Inuit art, offers an insight into an elemental and profound feature of Inuit life, history, and culture.

Bernadette Driscoll

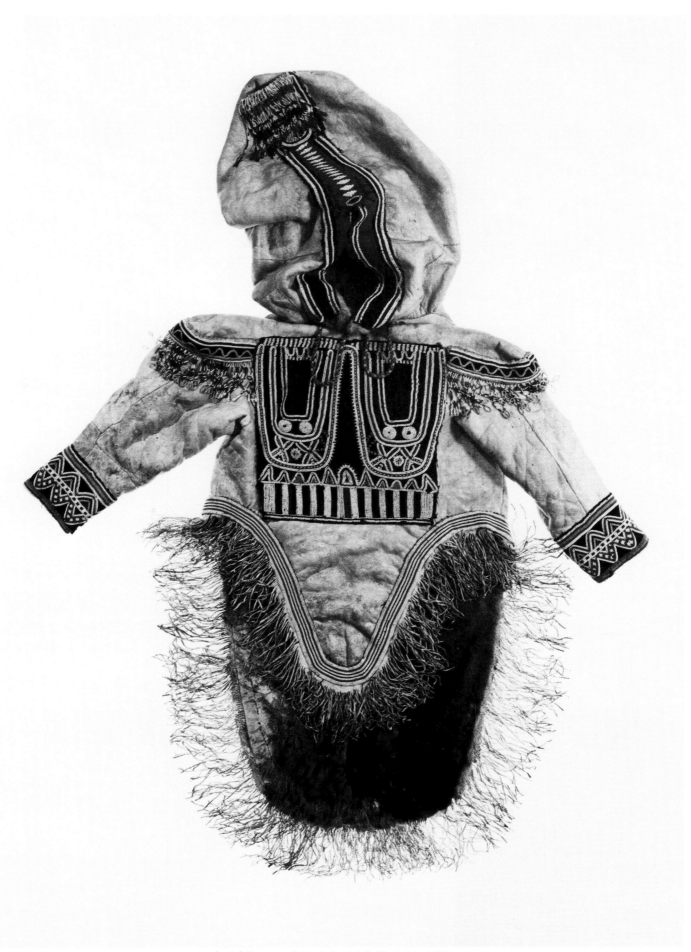

4. Adult woman's beaded *atigi,* Padlimiut, c. 1938.

71. LUKE ANGUHADLUQ, *Woman*, c. 1970

THE SYMBOLIC DESIGN
OF THE CARIBOU AMAUTIK

by George Swinton

There are obviously many ways to look at clothes and clothing, quite apart from the mundane aspects of conspicuous apparel, attire, dress, or simply covering. One may look at them, for instance, functionally, as a protection against, or a preparation for, and even an exploitation of, climatic conditions such as seasons or times of day, or rain or snow, of heat or cold, of wind or sun, and so forth and so on. Other functions may include identification of age; affirmation of social standing; professional and vocational associations; rituals; emotional expressions; aesthetic attitudes; ethnic traditions and profession of regional pride, to name just the most important that come to one's mind.

On the other hand, beyond those functions there are also symbolic implications, so that clothing does not merely describe the work, roles, ideas and attitudes of the wearers, but also helps the wearers to affirm that for which they think they stand, or pretend to stand, or actually do stand. These implications apply to all clothing including the rapidly, continuously, and unpredictably changing fashions of the modern Western world which stand in sharp contrast to the highly traditional clothing of the Inuit. Those changing fashions are seemingly aimed toward satisfying the tastes and fads of customers through the skills and "originality" of designers and manufacturers, yet instead they seem to expose an emptiness and aimlessness about our times in which our clothing and the rites of fashion reveal a heightened degree of status seeking, vanity, greed, and commercialism.

Clothing then communicates the wearer or about the wearer. On the other hand it can do more, for it can also enable the wearer to function more effectively both physically and psychologically. Clothing becomes then part of the "self" — that is, of that which William James calls "the sum total of all that [man] *can* call his" — which includes his physical, psychic, and symbolic existence. Ultimately then, clothing helps to identify man and, in turn, helps man to identify — or to disguise! — himself . . .

Among all the clothing with which I am familiar (including ritual vestments and uniforms of all kinds) the Eskimo *amautik* — the woman's parka with its pouch for the baby and its characteristic hood — is a supreme example of combining the functional, spiritual, and symbolic possibilities that a garment, or a single type of garment, is capable of offering. While all traditional fur clothing of Inuit men, women, and children, as well as most of their clothing made out of non-native materials such as duffle, nylon and even plastics, reflects the various attributes of sex, age, and work, the *amautik* does so more pronouncedly, more fully, more sensuously, and also both more figuratively and metaphorically. It identifies and symbolises woman, maturity, maternity, geographic regions, seasons, belief systems, and design traditions. It marks the origin and changes of Eskimo existence: it is a silent witness of the ways of life. It is a uniform of function and magic, of harmony with nature, of knowledge of animals, of understanding of materials, and of unshakable confidence in past traditions.

While Gudmund Hatt and Sylvie Pharand have very significantly discussed the *amautik's* physical characteristics, it was only Bernadette Driscoll who, so far, has started to examine the deeper meanings of the *amautik,* dealing as it were with its symbolic content than merely with its physical form. The exhibition before us reveals the rich possibilities of further content analysis of which I have singled out just one.

On the other hand, I must also admit that the aesthetic qualities of the *amautik*, with all the sensuous shapes which this wonderful garment has to offer, are very tempting indeed. And I can well imagine myself going into ecstatic descriptions of those sumptuous forms that speak as much of motherhood and soft embrace as of the fully female, or graceful strength and robust force. Yet there are also secrets underneath which simply beckon to be revealed.

For instance, in its design and in its cuts, the *amautik* not only parallels the actual locations of fur parts of the caribou and most of the specific qualities of various parts of the fur, including colour and strength, but it also graphically and symbolically follows the animal's main physical features. In this way the front and back of the *amautik* also reflect the caribou: the tail flap — the *akuq* — in the rear, the joint marks on the arms and, most of all, the *kiniq* — the front flap — with its priapic rudiments surrounded by the *pukiq* — the soft white fur of the caribou's underside.

It is, however, often difficult to talk freely about these animal relationships, for we no longer are in harmony with nature and therefore can no longer talk as we could if we and nature were in total unity. Inseparable and one: as humans and as animals. Commutable, permutable, reciprocal. A total give and take. Not the somewhat sentimentalized Edward Field version of "Magic Words" after Nâlungiaq's powerful story how *the hare makes the earth to be light.* In Nâlungiaq's own words, as retold by Knud Rasmussen,[†] she tells how "people and animals lived on the earth" on which "everything was in darkness" and that "there was no difference between them" and "they lived promiscuously", that is, "a person could become an animal, and an animal could become a human being" — they interchanged and reciprocated. In these times "that no one can understand now" were the times "when magic words were made" and "what people wanted to happen could happen" but "nobody could explain how it was" in those very earliest times when animals and human beings lived together; as one; without difference; in harmony . . .

These may have also been the times when human beings received from the animals their clothing and, as a sign of that communal interchange, the animal itself was incorporated in that which man now wears. Promiscuity had become union and clothing had become a sign that man and animals had become one, "lived in the same kind of house and spoke and hunted in the same way . . ."

The hunter's clothing resembled the animals, but the *amautik* also bore the symbols of oneness. As a sign of fecundity. Because the word had become sign and sign had become power. The *amautik* became magic — the magic of life. Through symbol and function. Designed for survival, the magic turned into form. The form having become content, while the words were long forgotten. Words from the very earliest times, that no one can understand any longer. But all know that this was the way it was. And I believe it could have been. Look at the signs!

† The Netsilik Eskimos, page 208

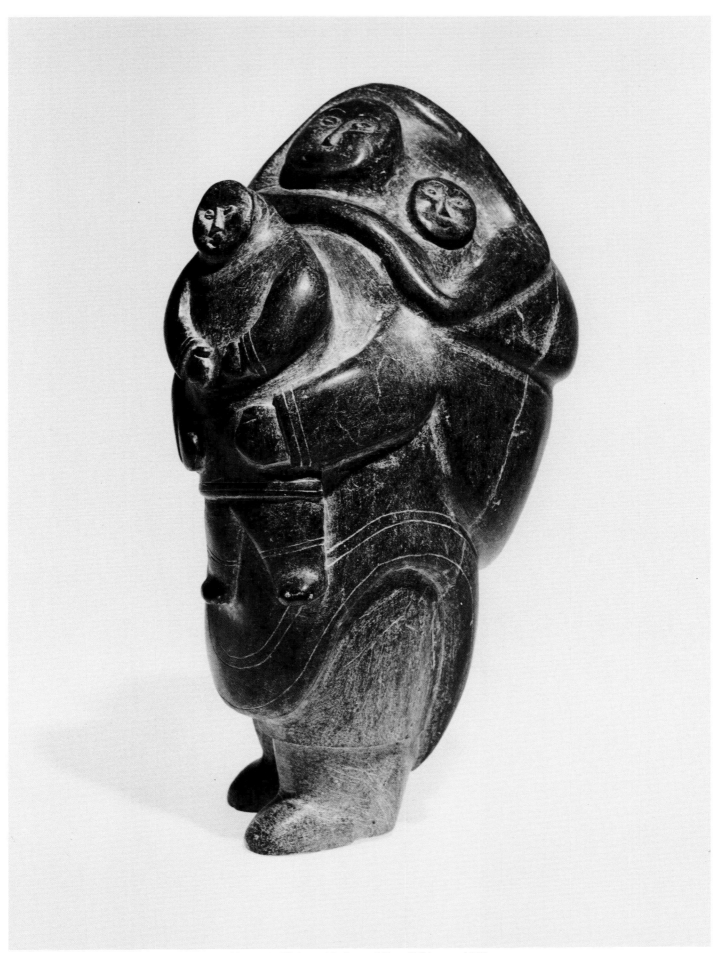

48. Annie Niviaxie, *Mother and Two Children*, c. 1966.

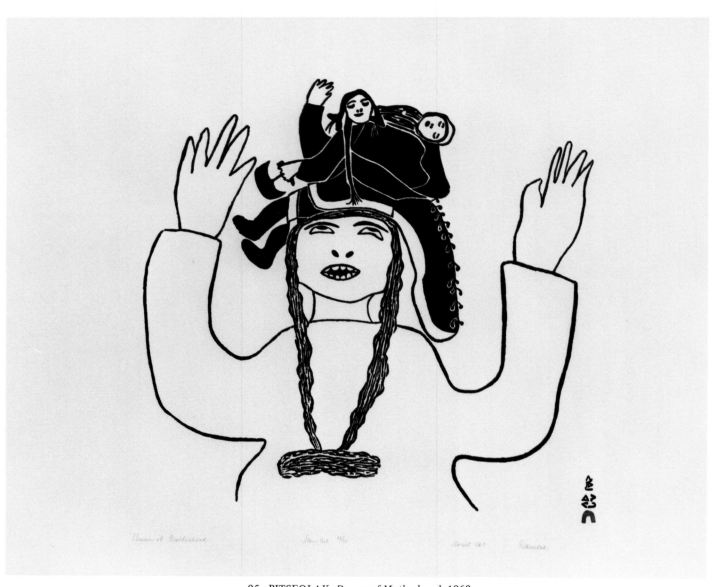

95. PITSEOLAK, *Dream of Motherhood,* 1969

THE AMAUTIK IN INUIT ART AND SOCIETY

Youth and the Dream of Motherhood

As a child a girl wore a parka similar to that of a boy, with no indication of *kiniq* or *akuq* (77, 51). If a young girl was a particular favorite of an aunt or grandmother, she might be given a miniature *amautik*, similar to her mother's in its design. In the tiny *amaut*, she could carry about her dolls or perhaps a small pup. When a girl reached the age of ten or eleven, she began to wear a modified version of the *amautik* (1). Although the hood was still small, both the *kiniq* and *akuq*, distinctive features of the woman's parka, were present. In the print by Iksiktaaryuk of Baker Lake (81) the women of the community have been called together in a large snowhut. In the centre stands a young boy. The mood conveyed by the work is that of an initiation rite — but for the women or the young boy? The title of the print, *An Ancient Way of Dancing,* serves as the only clue to its meaning.

At the start of menstruation, a girl's preparation for her adult role began in earnest. Traditionally, it was at this time that she was tatooed. Tatooing was considered a mark of beauty, but it also had magico-religious significance. Tatooed women were said to be "pleasing to Nuliajuk", the mistress of sea life. And it was only through tatooing that a woman could attain a rewarding afterlife. In this she was invited to join the most renowned Inuit hunters, for she had shown her willingness to suffer pain for the sake of beauty.

In tatooing, one of two methods was used, depending on the specific region of the Arctic. The first method was to prick the skin with a sharp needle, forming dot patterns on the face and limbs. Soot from the lamp (which itself is a symbol of the woman) was then rubbed into the fresh wound. The second method, practiced in the Central Canadian Arctic, was to draw the needle, threaded with sinew coated with lamp soot, under the surface of the skin. When the inflammation subsided, a continuous blue-grey line was clearly visible. The print by Oonark, entitled *Tatooed Faces* (88), shows a variety of facial tatoo configurations. Although the patterns of tatoo marks vary, the location (at the forehead, across the cheeks and below the chin) remains uniform. George Swinton has remarked on the similarity between tatooing and wrinkling, suggesting that tatooing may be associated with wrinkling as a symbolic reference to age, experience, and wisdom.[1]

The start of menstruation served as the sign of a girl's readiness for marriage. At this time she adopted an *amautik* closely resembling that of the adult woman. The distinctive features of the woman's parka, the long maternal hood, elaborated *kiniq*, and the *akuq* were fully present (2, 3). The print by Pitseolak, *Dream of Motherhood* (95), is a beautiful illustration of a young girl's anticipation of her future life. In her dream, the girl carries a sleeping child in her *amaut*, while in her left hand she holds an *ulu*, poised in readiness for the meats her husband will bring back to her. The *akuq* of her parka is richly decorated, indicating her husband's success as a hunter.

In the portrayal of single women in the exhibition, each is remarkable for the woman's sense of pride, confidence, and strength which the sculptors (many of them men) communicate through their works. This is particularly true of the carving by George Tatanniq (57). The shoulders of the woman are thrown back and there is a sense of strength and massiveness shared between the rendering of the stone and the projected image of the woman.

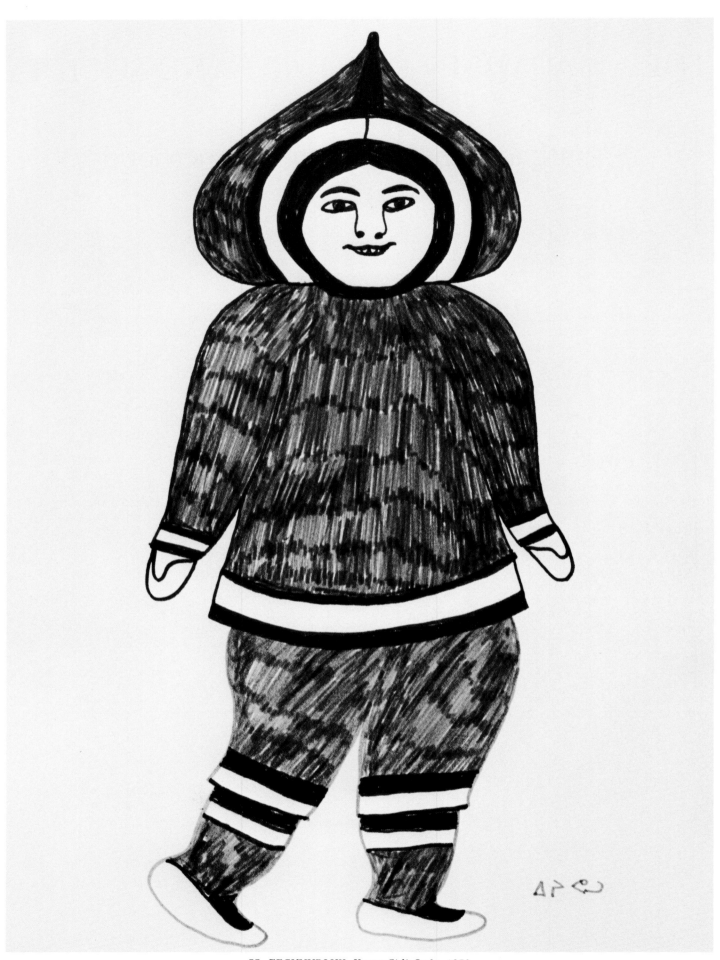

77. EEGYVUDLUK, *Young Girl's Parka*, 1972

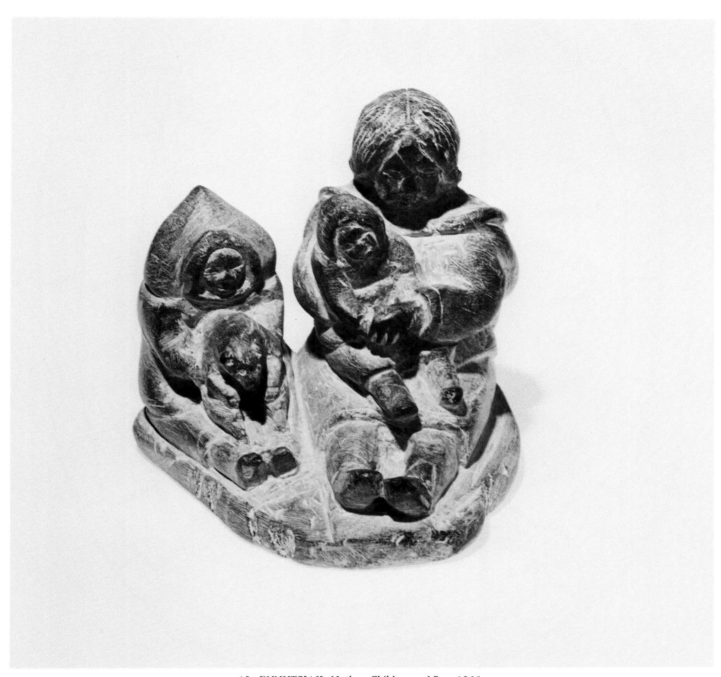

19. ENNUTSIAK, *Mother, Children and Pup,* 1966

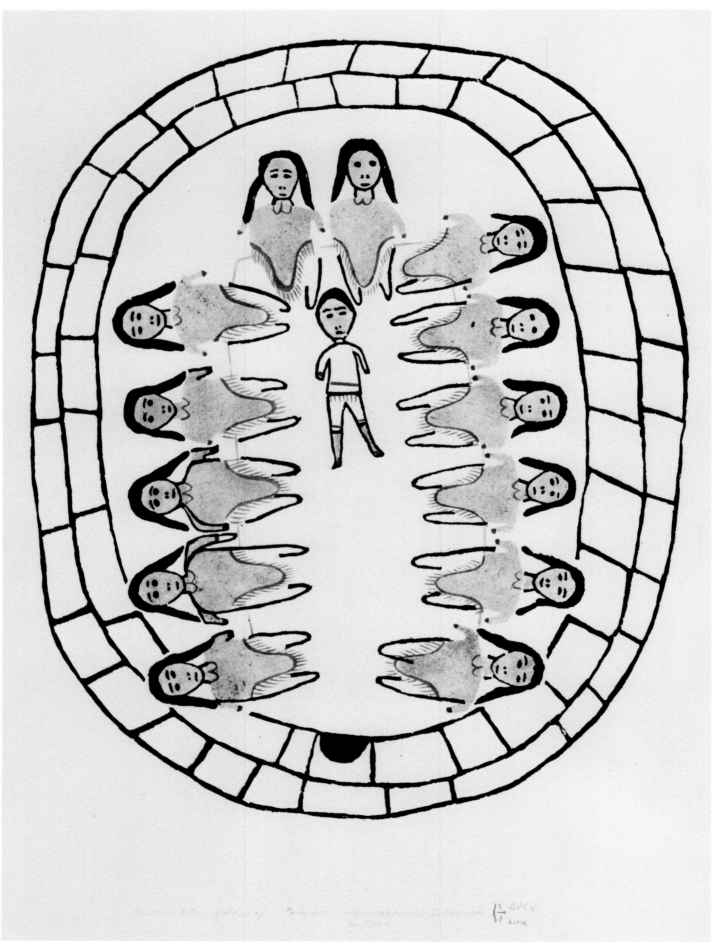

81. LUKE IKSIKTAARYUK/JAMES TIRIGANIAQ/MARTHA NOAH, *An Ancient Way of Dancing,* 1971

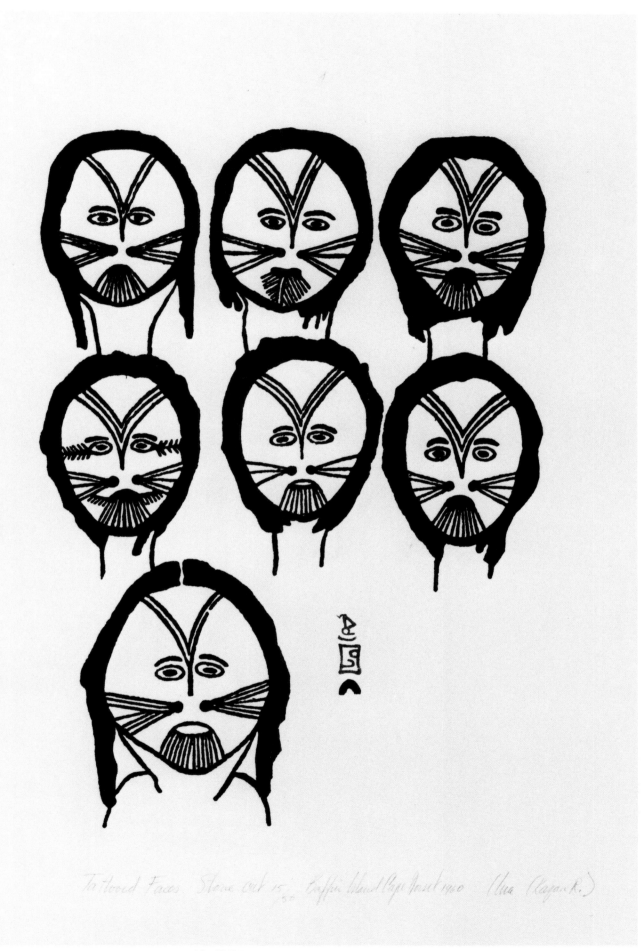

88. JESSIE OONARK (UNA), *Tatooed Faces*, 1960

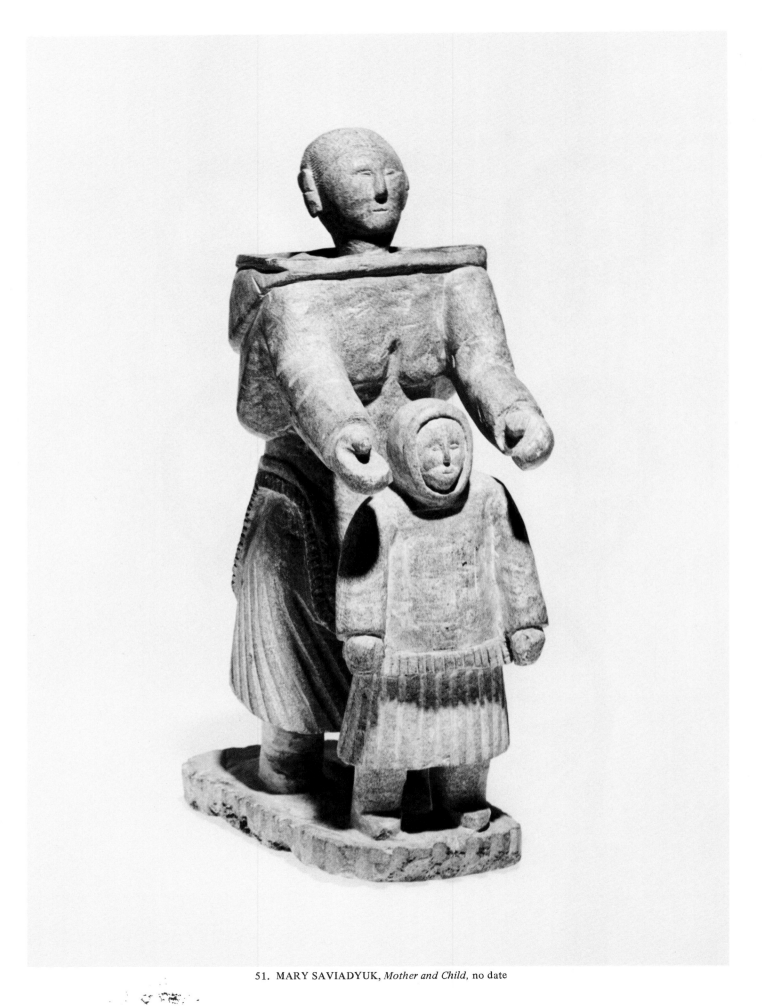

51. MARY SAVIADYUK, *Mother and Child,* no date

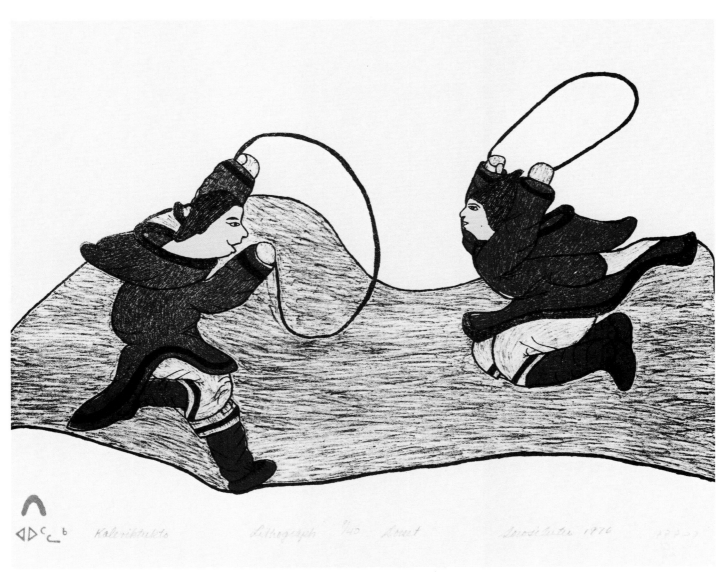

ᐯ
ᐊᐅᓐᑕ

Kaleviktukto *Lithograph* 9/40 *Cape Dorset* *Soroseelutu 1976*

98. SOROSEELUTU, *Kaleviktukto,* 1976

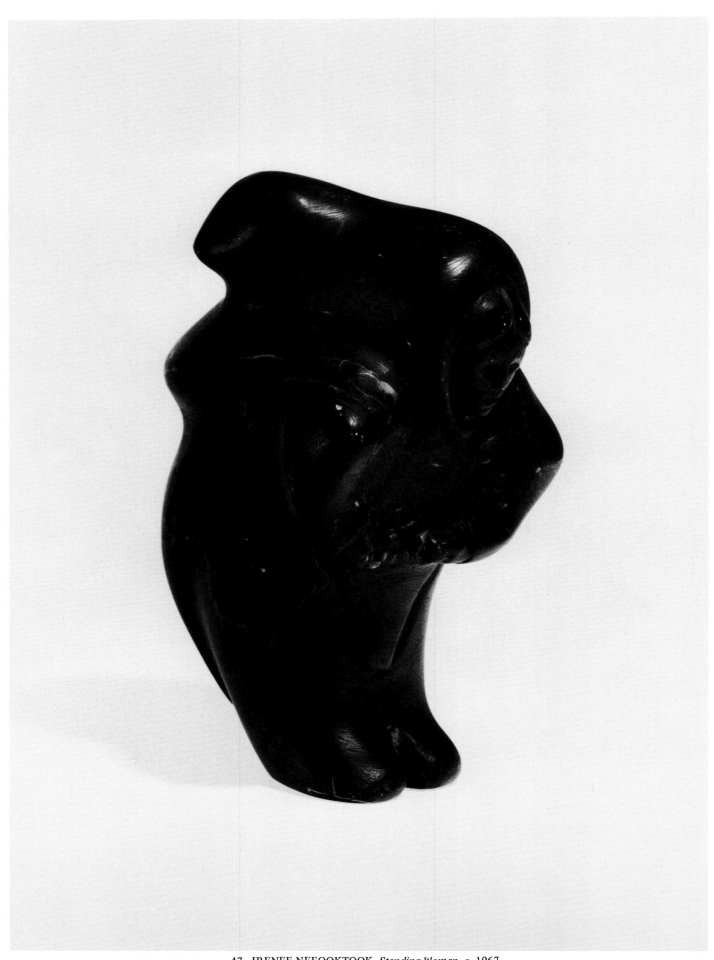

47. IRENEE NEEOOKTOOK, *Standing Woman*, c. 1967

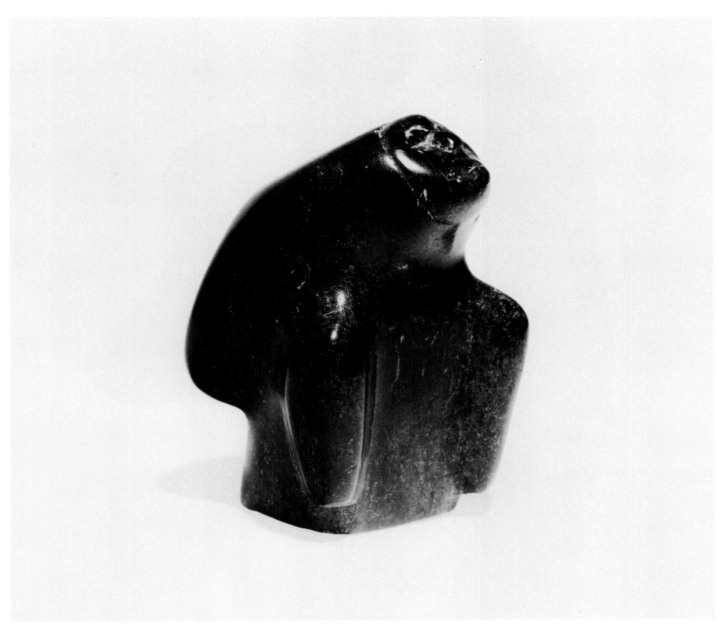

14. CECILE ANGMADLOK, *Woman*, 1972

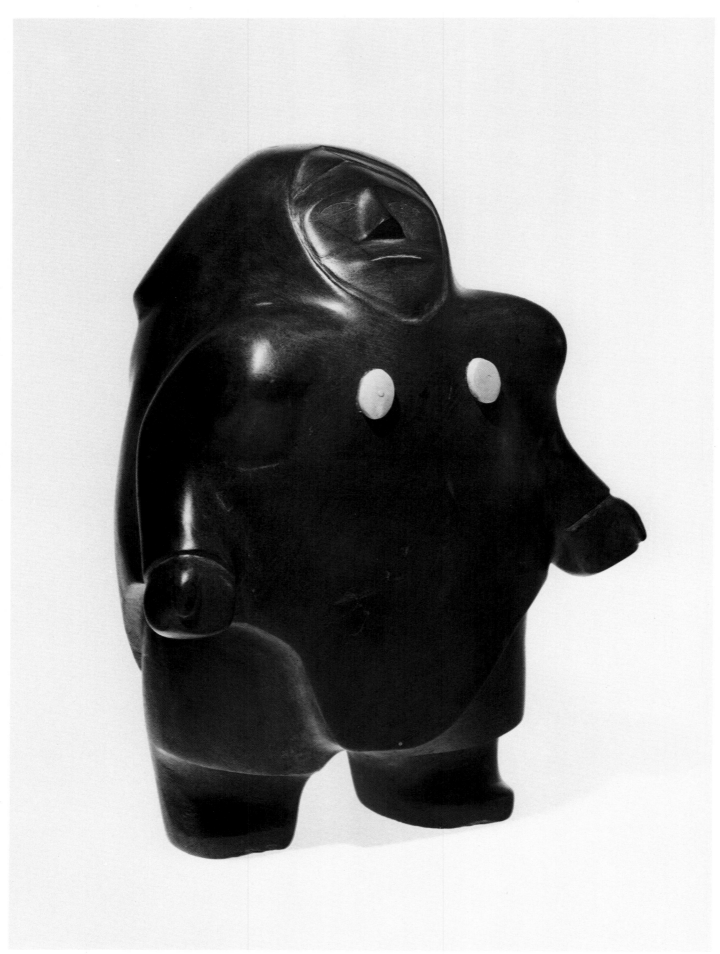

57. GEORGE TATANNIQ, *Woman*, 1973

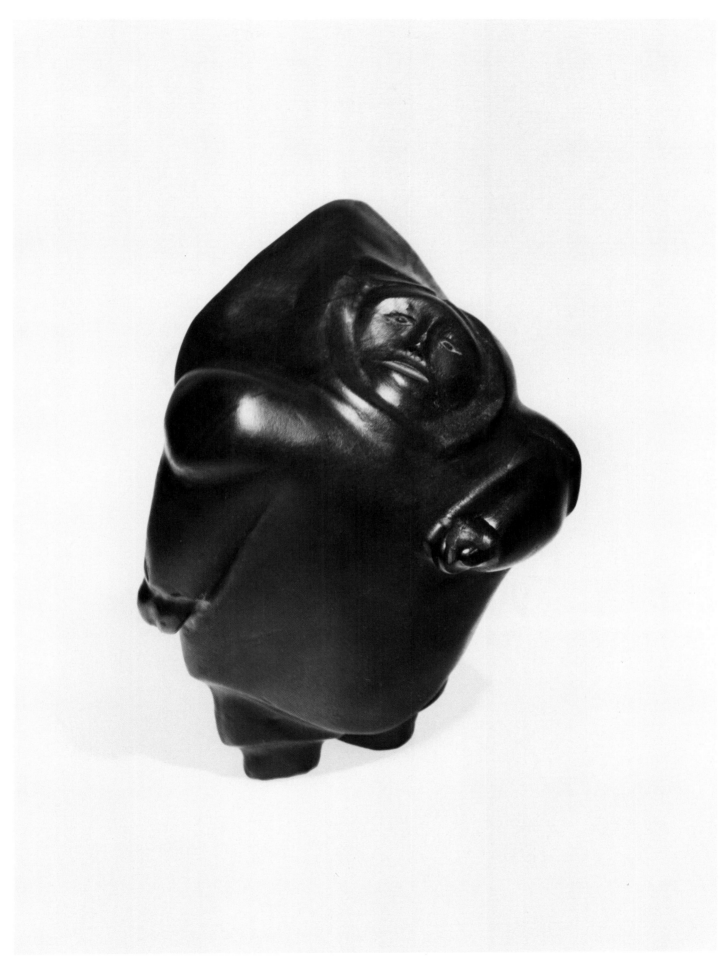

53. PETER SIVURAQ, *Standing Woman*, 1971

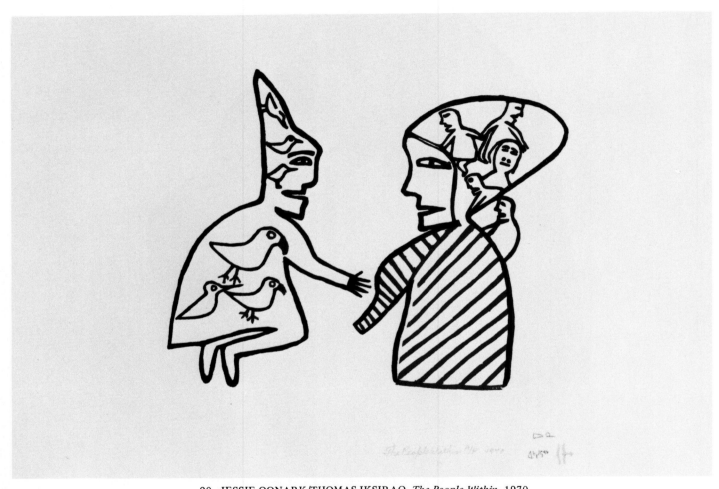

90. JESSIE OONARK/THOMAS IKSIRAQ, *The People Within*, 1970

Husband and Wife

Husband and wife form an economic unit in the traditional make-up of Inuit society. The unity between the married couple is shown in a carving by Isa Kasudluak of Inoucdjouac (28). The two figures stand independently of each other but are carved out of a single stone which forms the base upon which they stand. In (37), by Lew of Arctic Bay, husband and wife are not only carved out of the same stone but are joined together back to back as if to suggest their inseparable and symbiotic union.

The particular skills practiced by each sex were essential to the survival of the other. The duty of the man was to hunt, while the duty of the woman was to care for family and home. *The People Within* (90), by Jessie Oonark, graphically portrays the distinction between the roles of the two sexes: pictured within the parka of the man are images of various animals symbolizing the male's responsibility for the hunt; within the woman's parka, float human figures referring to her responsibility for procreation. Similarly, the drawing by Anguhadluq, *Family with Fish Catch* (69), shows the child carried on the woman's back, while the day's catch is carried in an *amaut*-like pouch on the back of the man.

Since the partnership between a man and a woman was so fundamental to survival, it was not uncommon for Inuit parents to betroth their children at birth. If the two families lived in the same general area, the young woman knew her husband-to-be throughout her childhood. Even as a young child, she might refer to him as "my future husband".

If the parents had not provided for a girl's marriage before her adolescence, a desiring young man (or his parents on his behalf) might then have approached the girl's father. For the price of a sledge, a kayak, or an object of similar value, the girl's hand was won. If an obstacle stood in the way of marriage — an objecting father or an existing husband or a reluctant fiancée — a man might have attempted to take a woman by force (18). If this was the case, the individual had to be prepared to face the consequences. Often the father, former husband, or brothers of the woman would attempt (through physical force or magic) to regain possession of the woman. *Vengeance for a Woman* (83), a stonecut print by William Kagyut of Holman Island, appears to be a reference to such a situation.

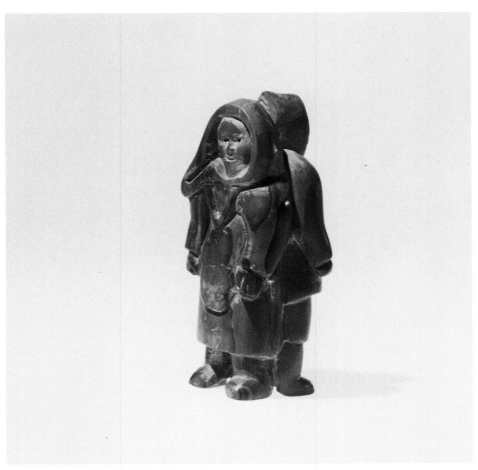

37. LOOTEE LEW, *Woman and Man*, 1963

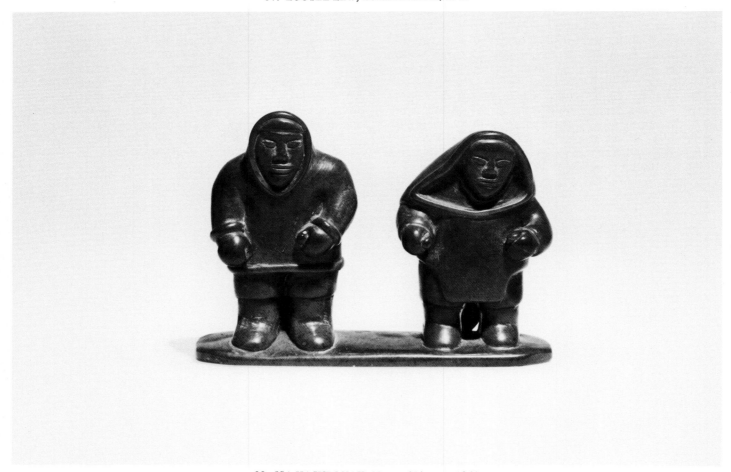

28. ISA KASUDLUAK, *Man and Woman*, 1961

82. MARTHA ITTULAKATNAK/VITAL MAKPAAQ, *Mothers and Children*, 1971

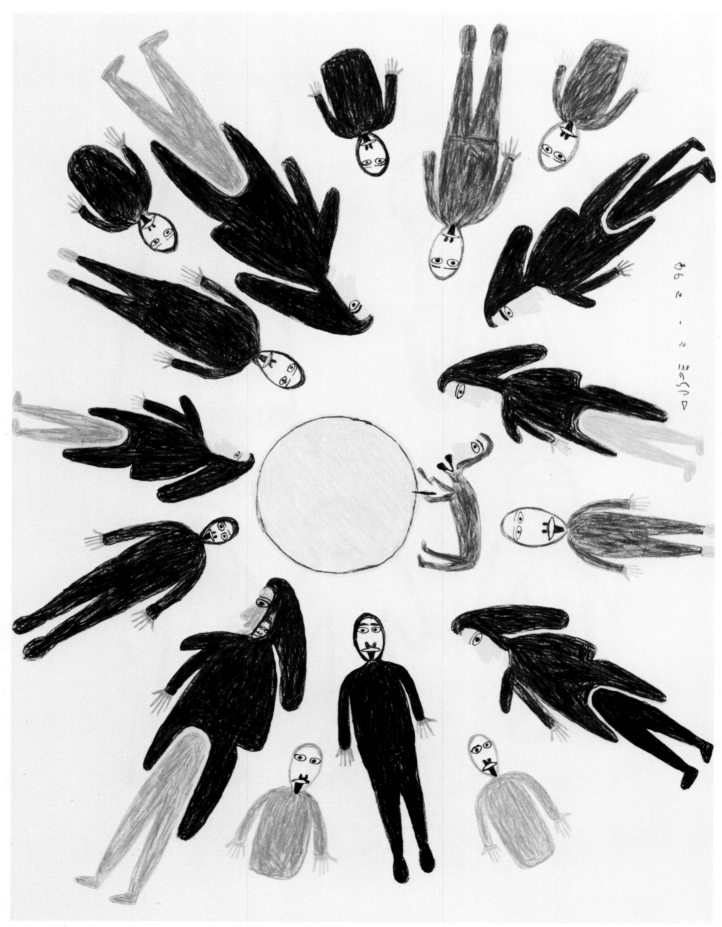

70. LUKE ANGUHADLUQ, *Drum Dance*, 1974

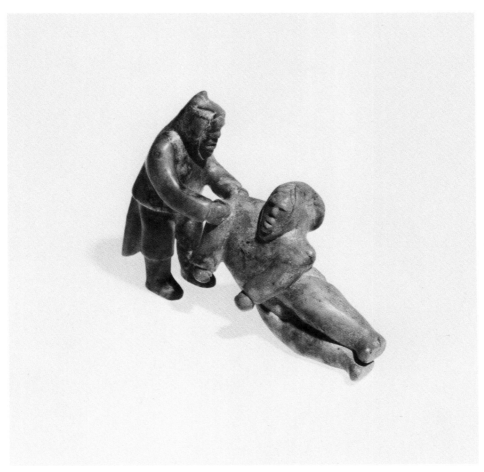

18. PATRICK EKALUN, *Man Dragging Woman,* no date

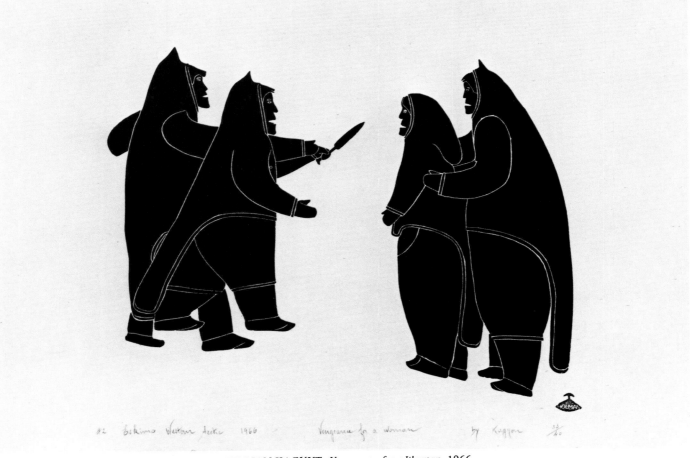

83. WILLIAM KAGYUT, *Vengeance for a Woman,* 1966

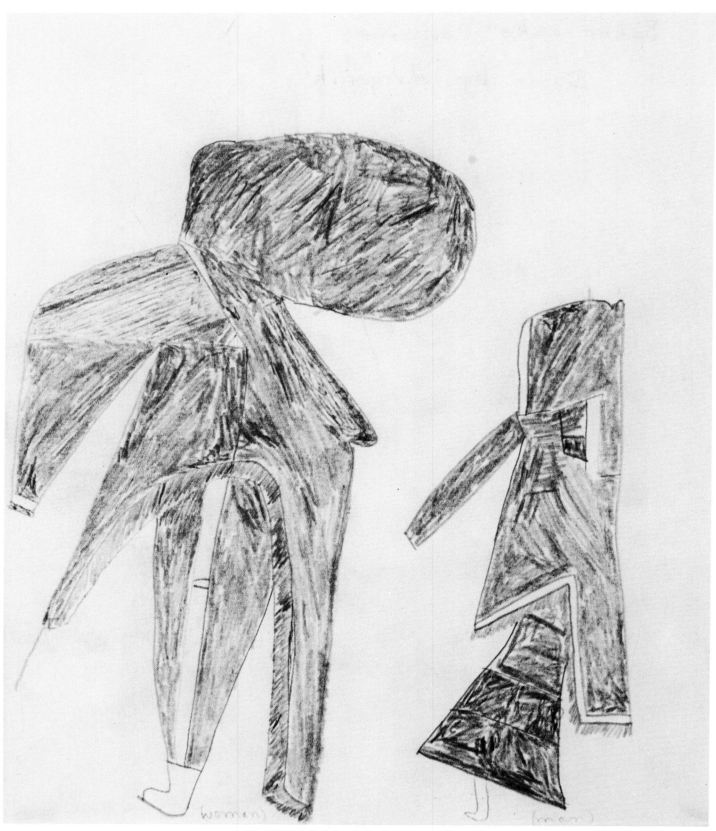

68. ANGENIK, *Baker Lake Costumes*, c. 1964

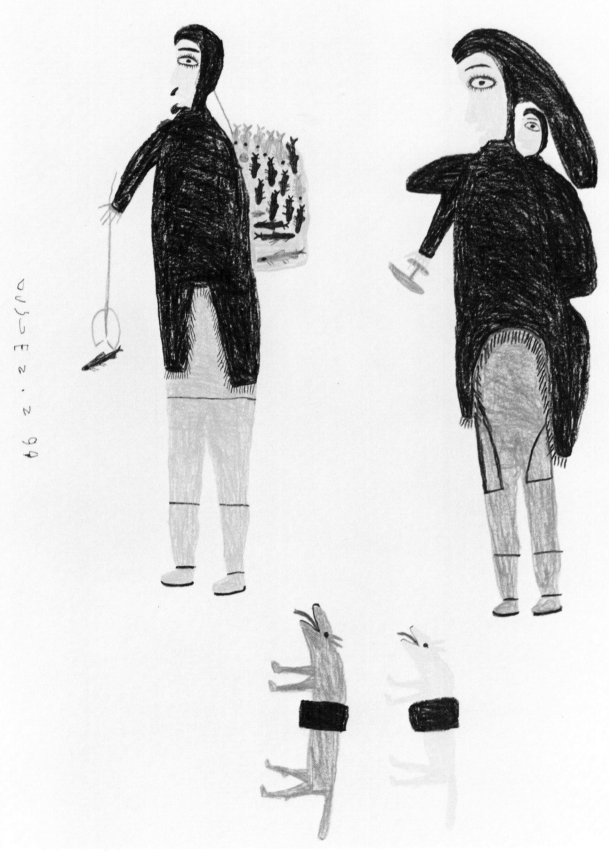

69. LUKE ANGUHADLUQ, *Family with Fish Catch,* c. 1971

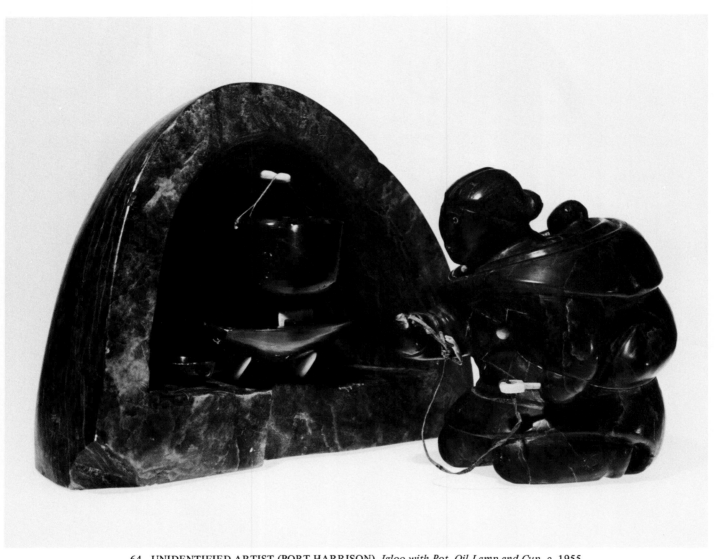

64. UNIDENTIFIED ARTIST (PORT HARRISON), *Igloo with Pot, Oil Lamp and Cup,* c. 1955

65. UNIDENTIFIED ARTIST (PORT HARRISON), *Woman,* c. 1955

CHAPTER III

Women and the Home

Traditionally, the responsibility of the woman centred around the home. In the carvings by both Johnassie Kavik (33) and Timothy Naralik (44), the artists have placed the figure of a woman on a flat base, physically defining the area occupied by each. This base, creating the impression of a location fixed in space, refers to the woman's association with the home. The symbols of the woman's domestic role are present in the two carvings: the blubber lamp which gives light and warmth; the soapstone pot in which food is prepared; the trunk containing the valuable possessions of the family; and a pair of boots, showing the woman's care for the physical protection of her family. In (33), the woman carries a child in the *amaut*. Although the infant is not visible in the carving by Naralik (44), the position of the woman's head suggests that she is talking (singing?) to a child hidden in the parka behind her.

In contrast to the woman's association with the home, the man's association is with the hunt. His most valuable possessions are his hunting equipment and means of transportation (sledge, kayak, or both). These objects, which are light and portable, symbolize the necessary mobility of the hunter. Conversely, the heaviness of the woman's possessions — the soapstone pots and blubber lamp — suggest a sedentary and settled position. Only the *amautik* makes reference to the particular mobility of the Inuit woman.

In the *amautik*, the child accompanies the mother throughout her day (96, 32, 33, 44, 27, et al.). The playfulness between mother and child, as well as scenes from the daily work of the woman, are a popular subject in Inuit art. The figures of women at work — whether stretching a boot (46) or scraping a sealskin (34) — are portrayed with a sense of dignity and presence which transcends (and celebrates) the everyday nature of the subject.

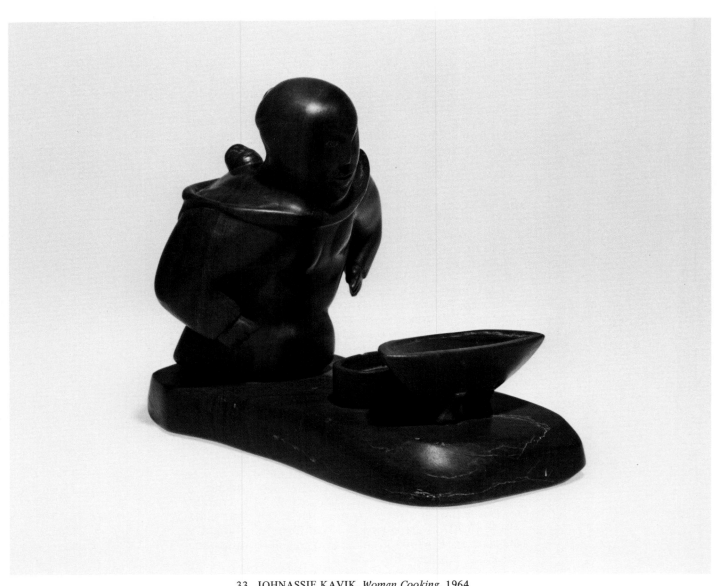

33. JOHNASSIE KAVIK, *Woman Cooking,* 1964

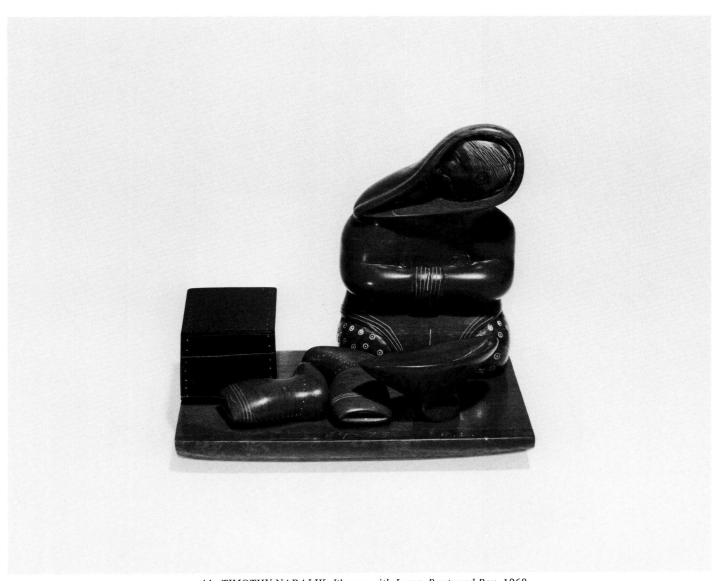

44. TIMOTHY NARALIK, *Woman with Lamp, Boots and Box*, 1968

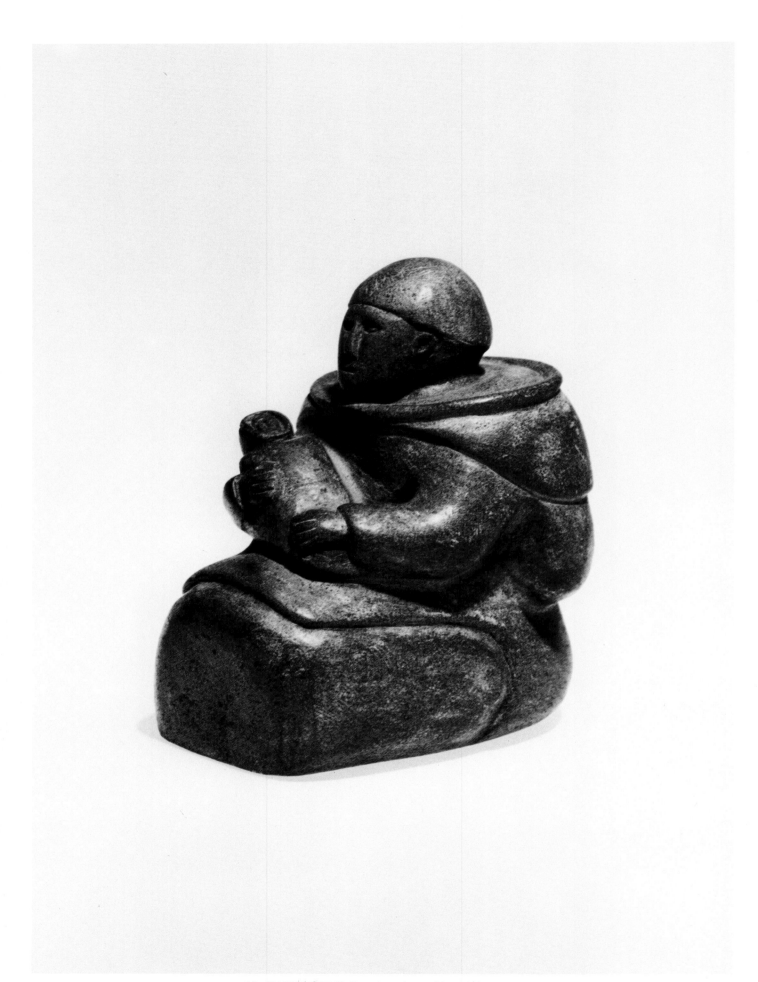

38. MARY LUKASI, *Seated Mother Holding Child*, c. 1959

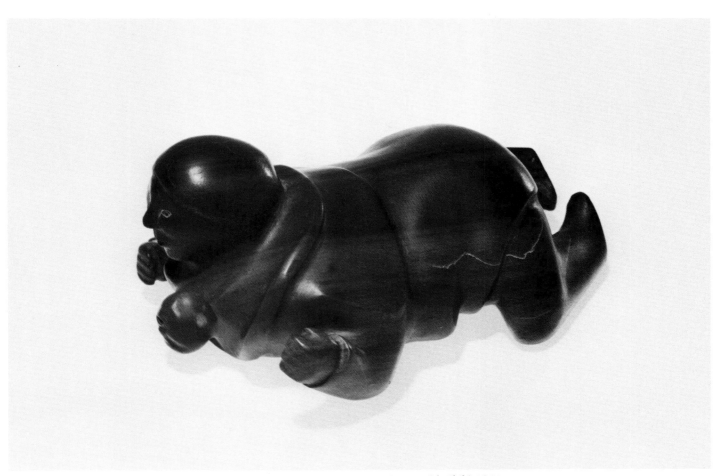

32. JOHNASSIE KAVIK, *Crawling Woman with Child,* 1964

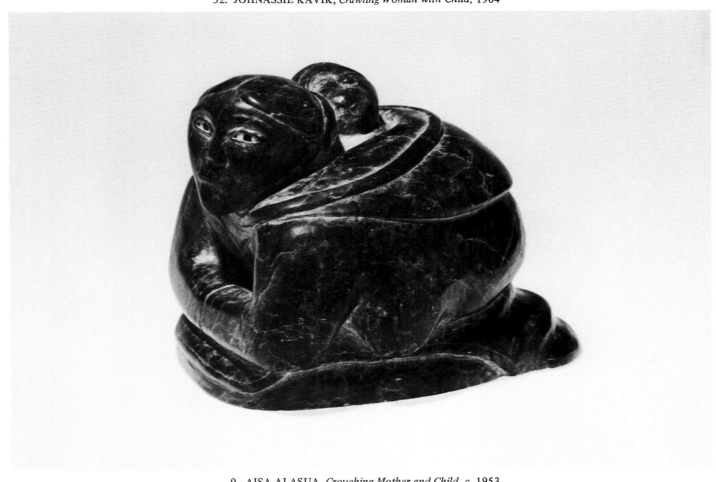

9. AISA ALASUA, *Crouching Mother and Child,* c. 1953

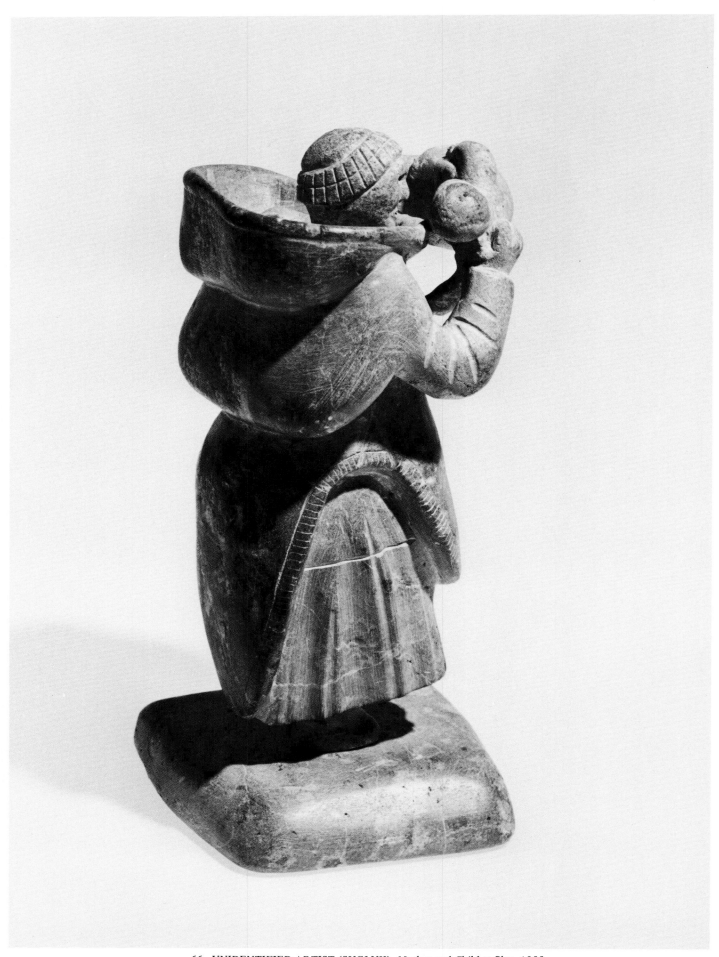

66. UNIDENTIFIED ARTIST (SUGLUK), *Mother and Child at Play*, 1955

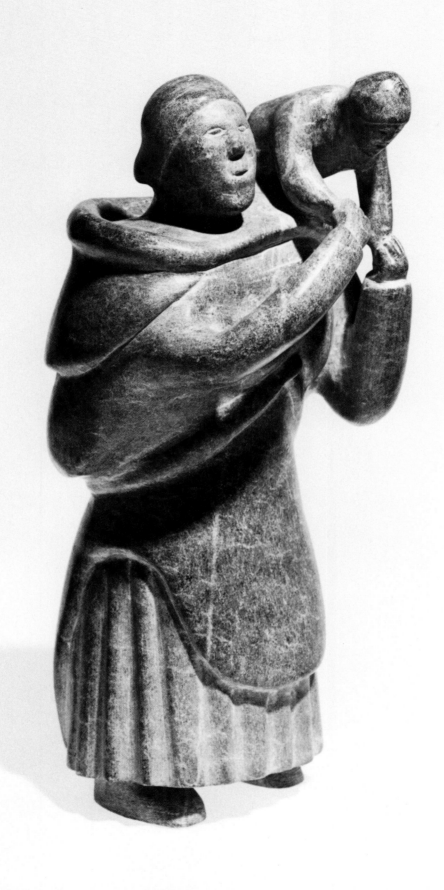

27. MAGGIE ITUVIK, *Woman Holding Child*, c. 1963

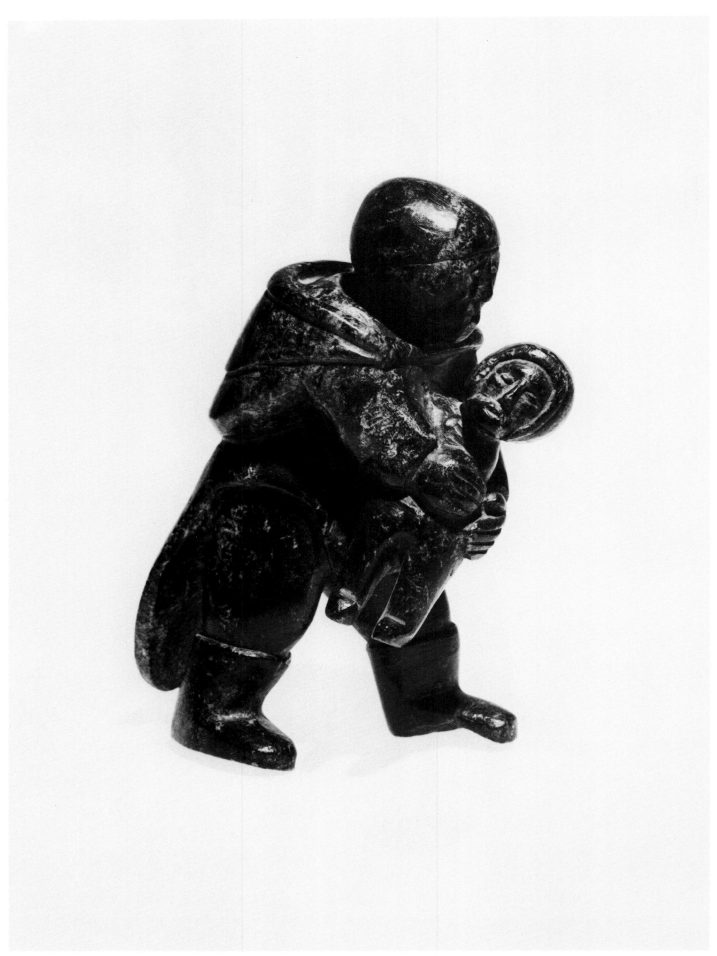

26. MARY IRQIQUQ, *Mother Holding Child*, 1953

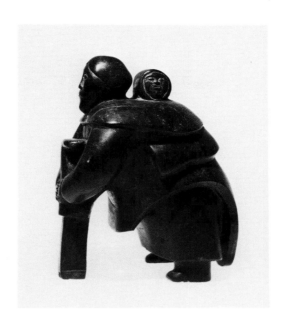

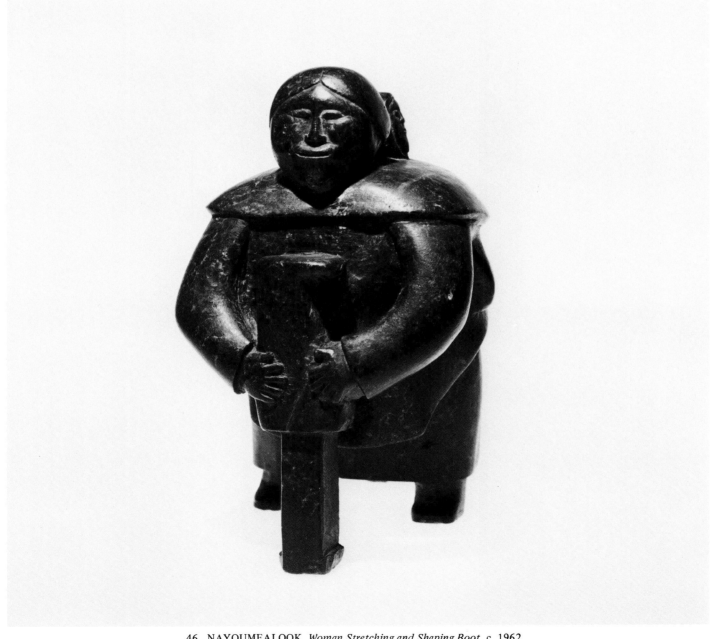

46. NAYOUMEALOOK, *Woman Stretching and Shaping Boot*, c. 1962

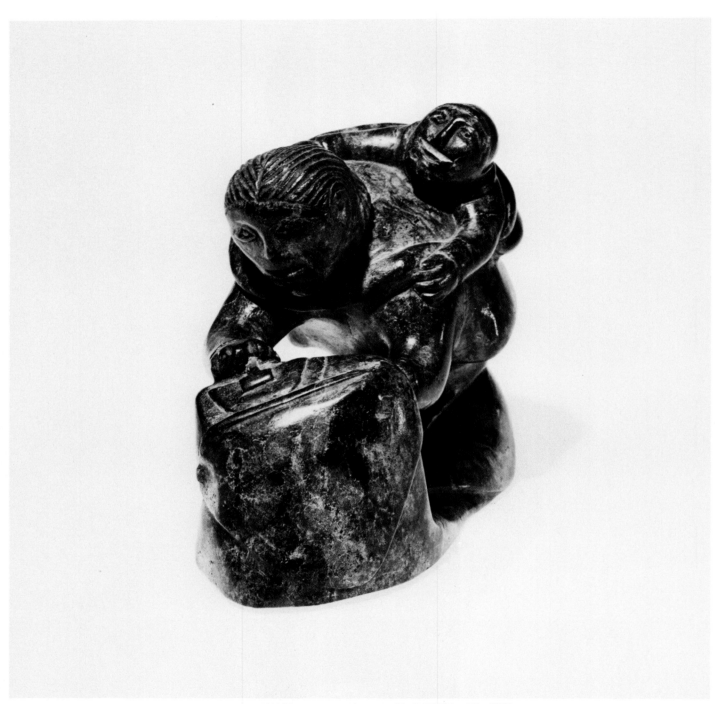

34. TOKAK KIATAINAQ, *Woman with Child Using Ulu*, 1961

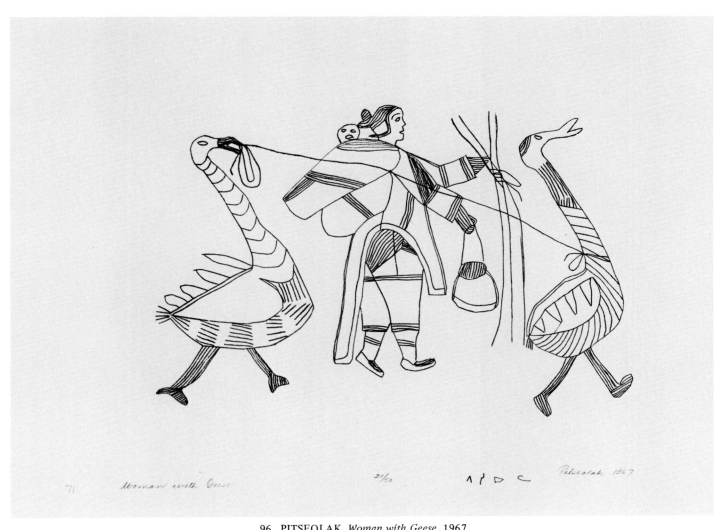

71 *Woman with Geese* ²¹/₅₀ ∧ ꕔ ▷ ᑕ Pitseolak 1967

96. PITSEOLAK, *Woman with Geese,* 1967

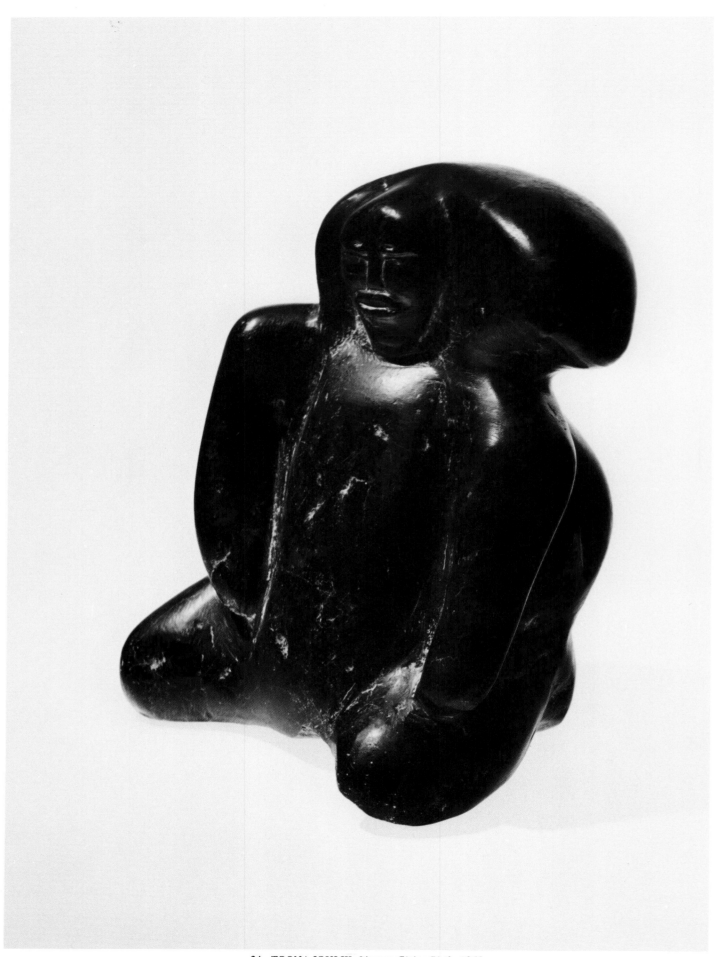

24. **TOONA IQULIK,** *Woman Giving Birth,* 1963

CHAPTER IV

Women and Birth

The intimacy of birth has not precluded its portrayal as a subject in Inuit art. In the carvings by Iqulik of Baker Lake, the woman is alone as she gives birth (24, 25?). Among many Inuit groups, it was forbidden for a woman to be given any assistance during labour or delivery. If this precept were ignored, the transgressor would be subject to the same strict post-natal taboos as the mother. However, if the life of the woman or child were endangered in the process of birth, a shaman might be called in for assistance. The invocation of a powerful shaman had great influence over a child's life; it could equip the child from that moment forward with the help of special guardian spirits, perhaps preparing the child for an extraordinary role within the community. The assistance of a shaman at birth appears to be the subject of a recent print by Helen Kalvak of Holman Island (84). The shaman can be recognized by the *pukiq* fringing which hangs from his parka.

The naming of the child took place at birth. The mother, or another female relative, if present, would call out the names of recently deceased persons in the community. It was believed that when the infant's soul heard its name being chanted, it was coaxed out of the womb. Naming a child after a deceased relative or friend was a reflection of the feeling and respect held for that person. It was believed that the spirit of the deceased would take a special interest in this new life and assist it through its many trials.

The period after birth was a time of intense spiritual significance. The body of the child was cleansed with the fetal skin of some animal whose characteristics were desired for the child's success. For example, when the fetal skin of the raven was used, it meant that the future hunter (like the raven) would always be present when game was caught. In the sculpture by Ennutsiak, *Midwives and Baby* (20), six women are gathered around the nude body of a male child. The right hand of each of the women is placed on a limb of the child's body. The hoods, drawn over the heads of two of the women, seem to indicate the presence of spirit forces.[2] In the carving by Lukassie Usuituayuk (60) a fish is draped over the ankles of the mother. This too might be an allusion to an initiation custom practiced on behalf of the young child she holds in her arms.

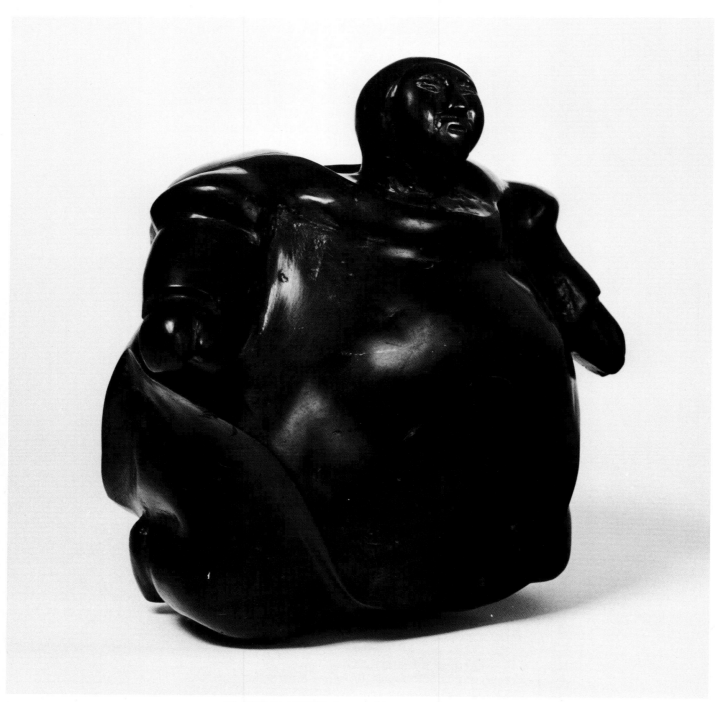

25. TOONA IQULIK, *Pregnant Woman Kneeling,* no date

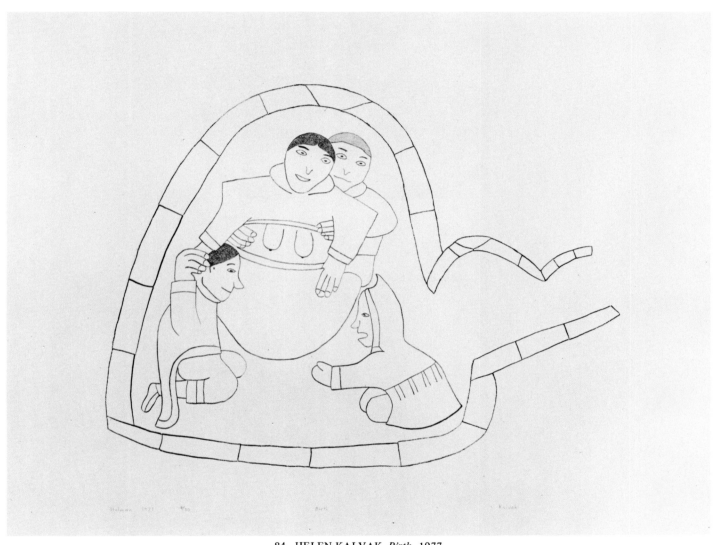

84. HELEN KALVAK, *Birth,* 1977

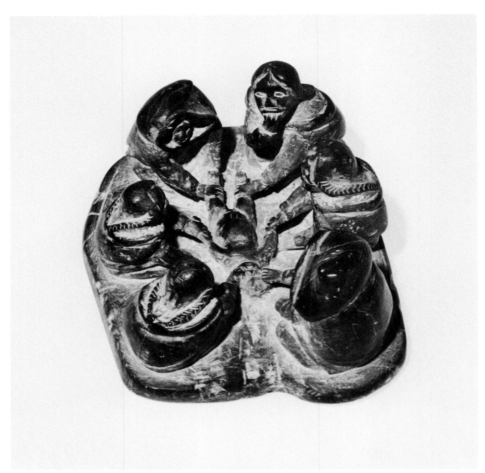

20. ENNUTSIAK, *Midwives and Baby*, 1965

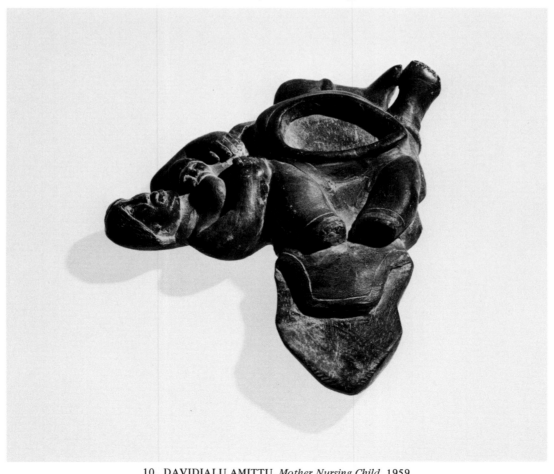

10. DAVIDIALU AMITTU, *Mother Nursing Child*, 1959

62

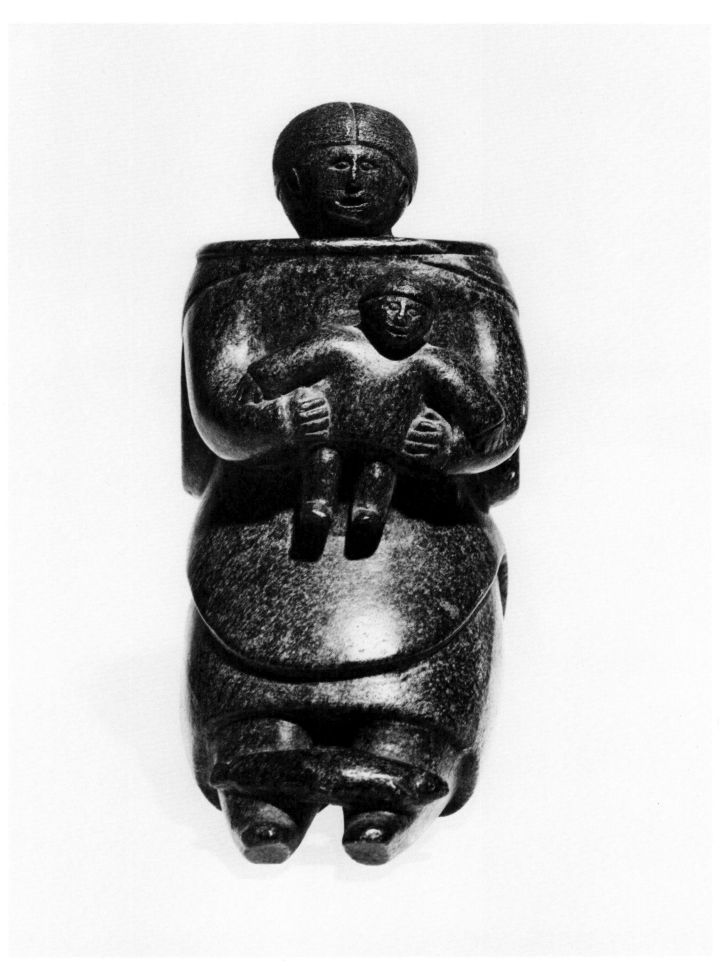

60. LUKASSIE USUITUAYUK, *Mother Holding Child*, 1954

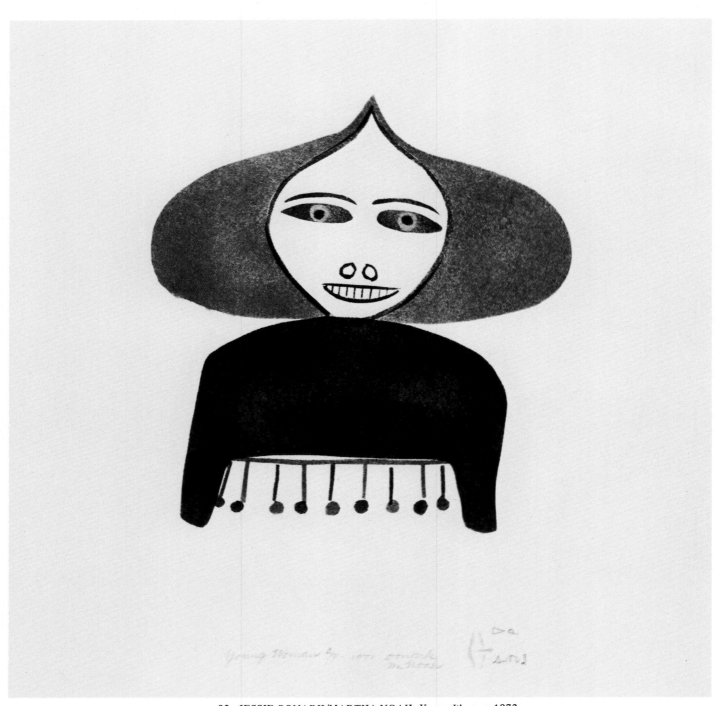

93. JESSIE OONARK/MARTHA NOAH, *Young Woman,* 1972

Regional Amautik Styles

The regional variations in *amautik* style across the Arctic are represented in contemporary Inuit art. Until the early part of the 20th century, the style of *amautik* was, indeed, strictly determined by region, and the appearance of the *qulittaq* was more or less uniform within a region. A print by Oonark of Baker Lake, *Woman* (94), shows the style of *amautik* worn in the interior of the Central Arctic. In 1960, Oonark (Una) submitted a drawing of the inland style of *amautik* to the Cape Dorset printmaking project. The strong vertical orientation of the parka, with its accentuated shoulder and elongated hood (89), may have been the printer's interpretation when cutting the stone, due to the sharp contrast between the design of the local Baffin Island *amautik* (78, 79), and the traditional *amautik* of the Central Arctic interior.

The evolution in *amautik* styles, which has taken place as a result of *qablunaat* influence and increased opportunities for travel among Inuit, becomes evident in comparing various works included in the exhibition. In the two sculptures by Akeeaktashuk of Inoucdjouac, one (7) shows the traditional sealskin *amautik* of the area with its sharply defined *kiniq* and *akuq*; the other (6) shows the *angijurtaujuq* introduced through the influence of visiting whalers. Daniel Angitookalook of Great Whale River shows a woman dressed in the ankle-length Mother Hubbard, a style originally introduced in the Western Arctic which has gradually made its way eastward. In the same vein, *Women's Clothes* (80), by Emerak of Holman Island, illustrates the traditional cut of the Copper parka in the Western Arctic, while *Dance for a Visitor* (87), drawn by Nanogak, also of Holman Island, features an imported Alaskan style of *amautik*.

Regional differences in parka design were always of special interest to Inuit. Incorporating design features in one's own parka from a neighboring, or better still, far distant community, was a sign of prestige and an indication that one was well-travelled. In the home, small dolls which could be dressed in miniature parkas were used as toys for children. (55, 61).

The earliest works in the exhibit, photographs taken by the A. P. Low Expedition (1903-04), show the influence of Western material on dress in the vicinity of the whaling stations on the west coast of Hudson's Bay. In addition to the elaborate beadwork, three of the women pictured in one photograph (101) are wearing long cotton print skirts under the *atigi*. Two of the skirts have obviously been cut from the same bolt of material. The felt pen drawings by Eegyvudluk and Ulayu of Cape Dorset (78, 79, 99) also show the use of Western trade objects in decorating the *atigi*. In one drawing by Eegyvudluk (79), a column of coins or medals is placed in a single row down the *akuq* of the parka. The term for this type of decoration (*akoosik*) apparently takes its name from its placement on the *akuq*.

In addition to decorating the parka, beads and other trade items were also used for decoration on one's person. Copper and brass were beaten down to form a thin plate of metal which was worn across the forehead. Long strands of beads dangling from the side of the head over the ears soon replaced the traditional hairsticks and were worn especially on festive occasions (23).

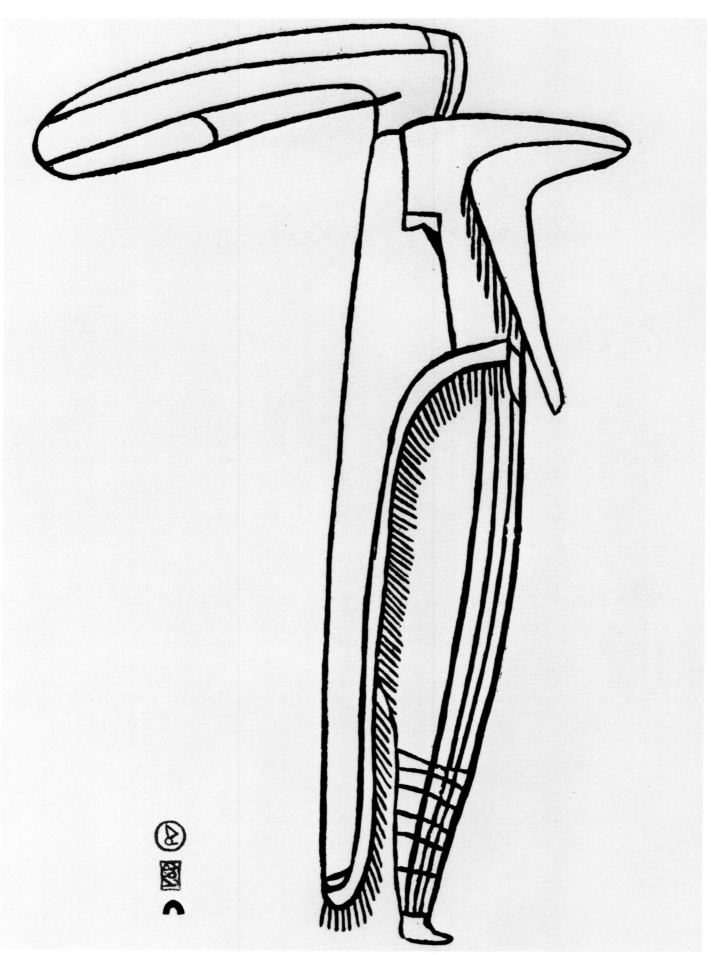

89. **JESSIE OONARK (UNA)**, *Inland Eskimo Woman*, 1960

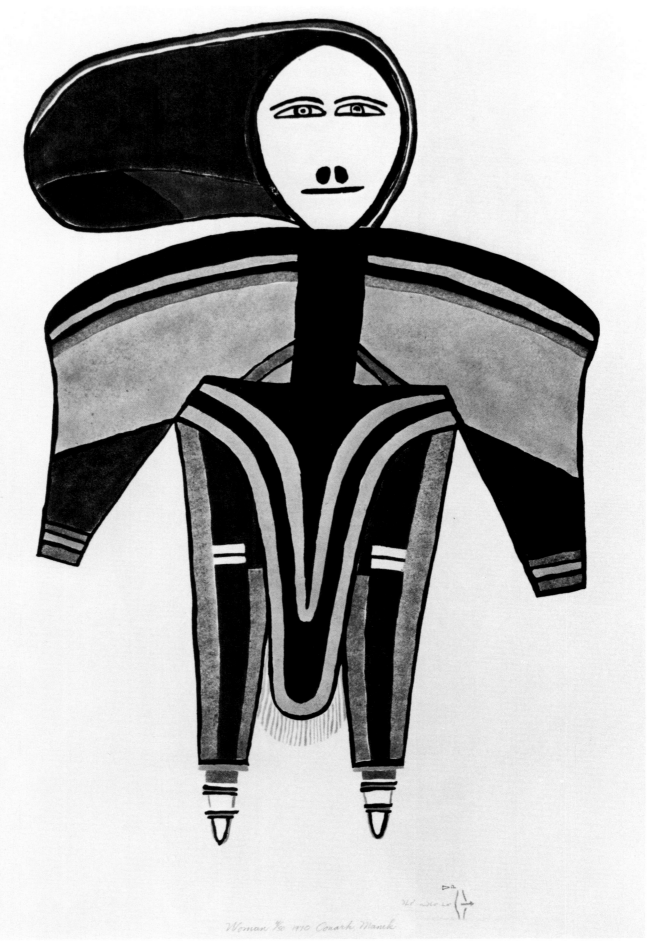

94. JESSIE OONARK/THOMAS MANNIK, *Woman,* 1970

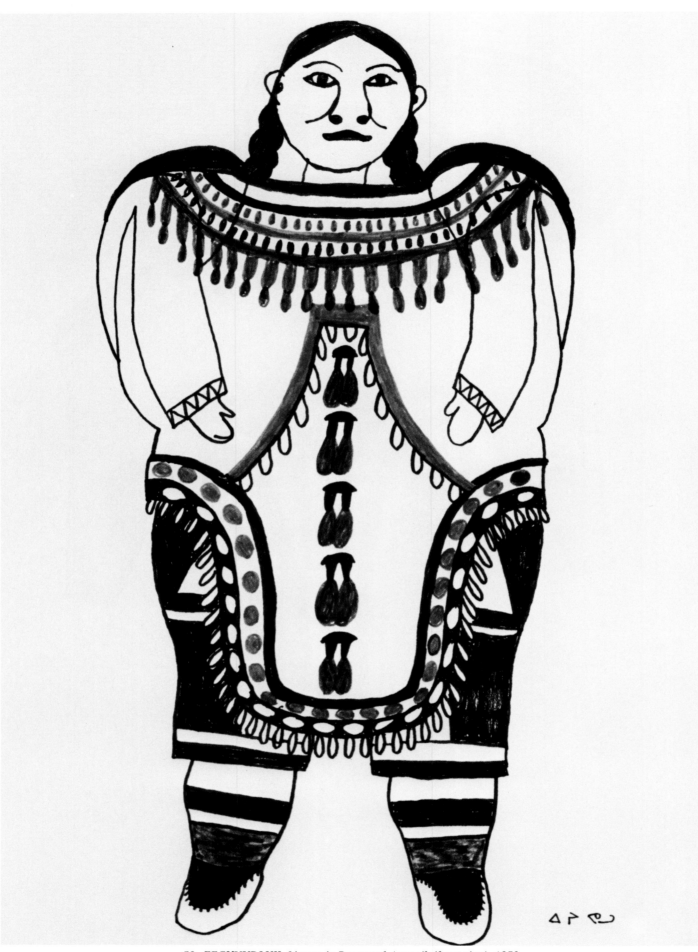

78. EEGYVUDLUK, *Woman in Decorated Amautik* (front view), 1972

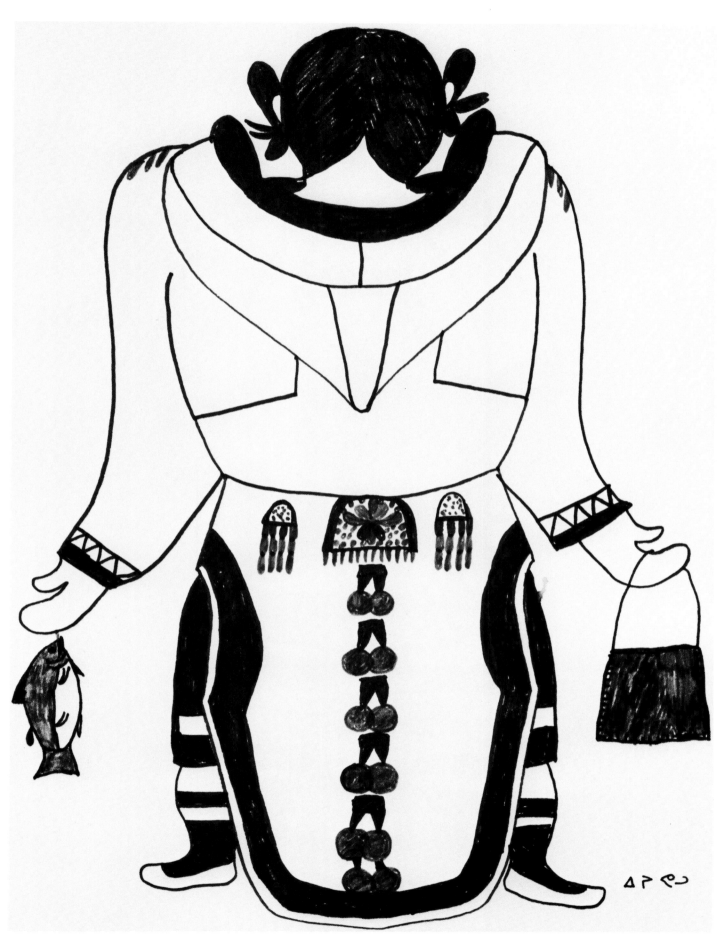

79. EEGYVUDLUK, *Woman in Decorated Amautik* (back view), 1972

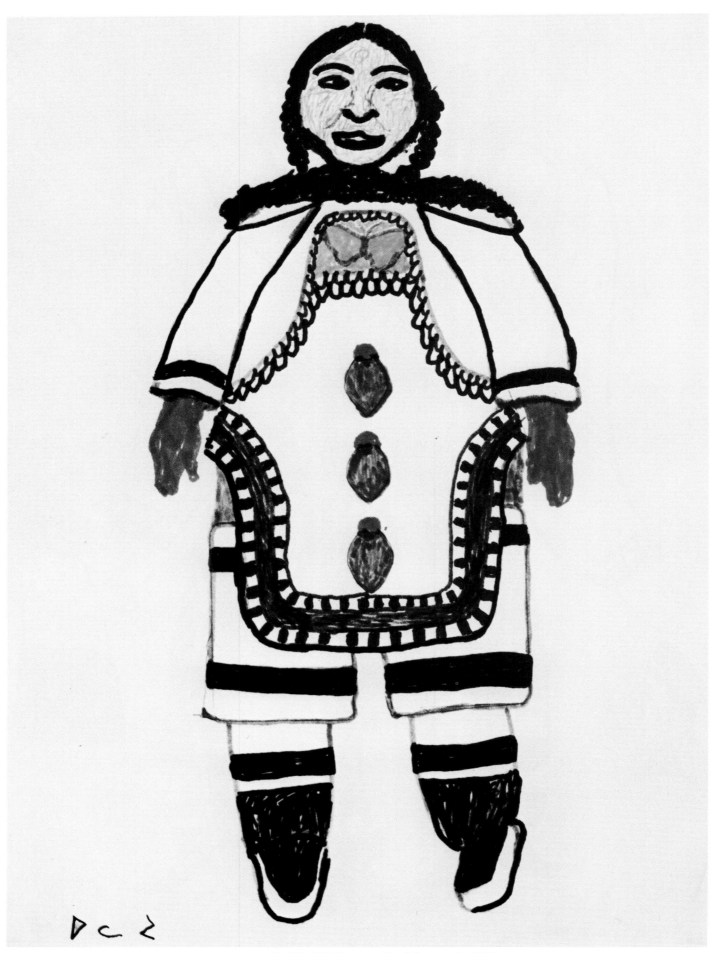

99. ULAYU, *Woman in Beaded Amautik,* 1972

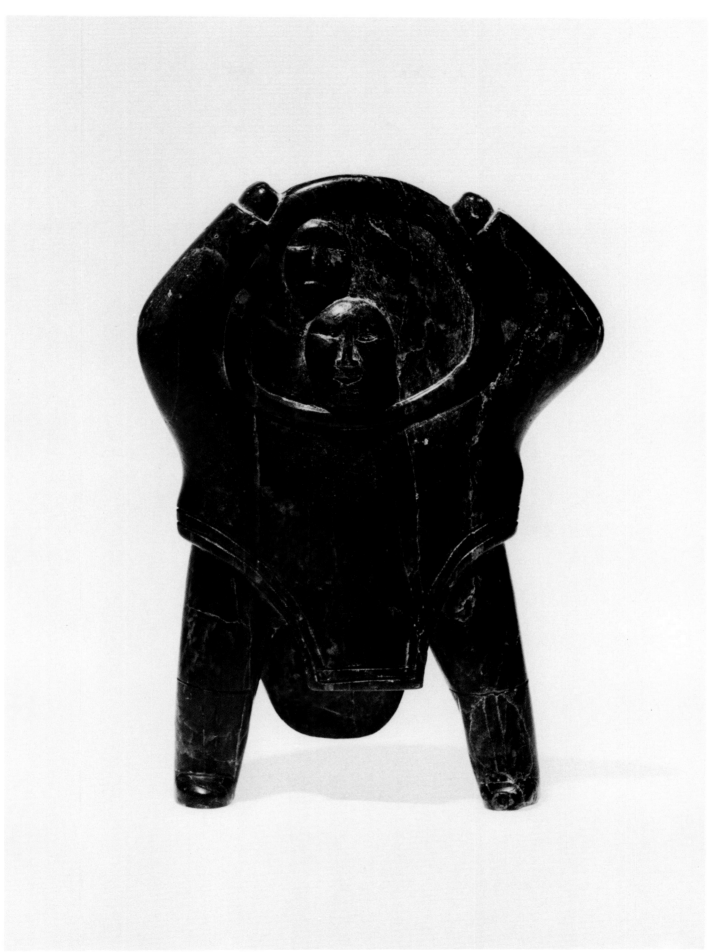

7. AKEEAKTASHUK, *Mother and Child*, 1953

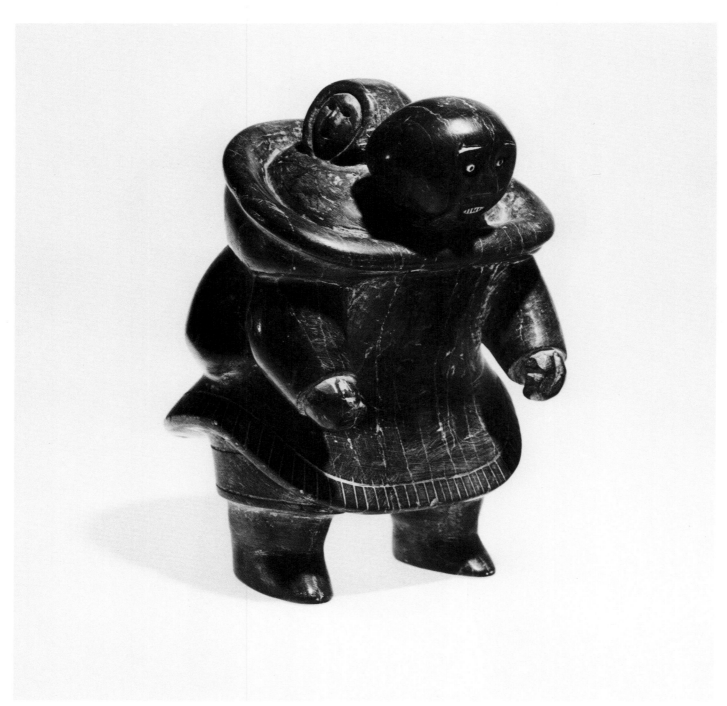

6. AKEEAKTASHUK, *Mother and Child*, 1953

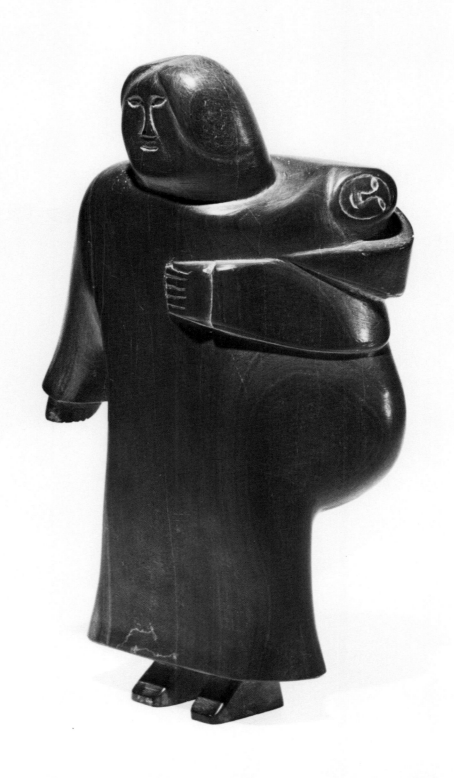

13. DANIEL ANGITOOKALOOK, *Mother and Child,* no date

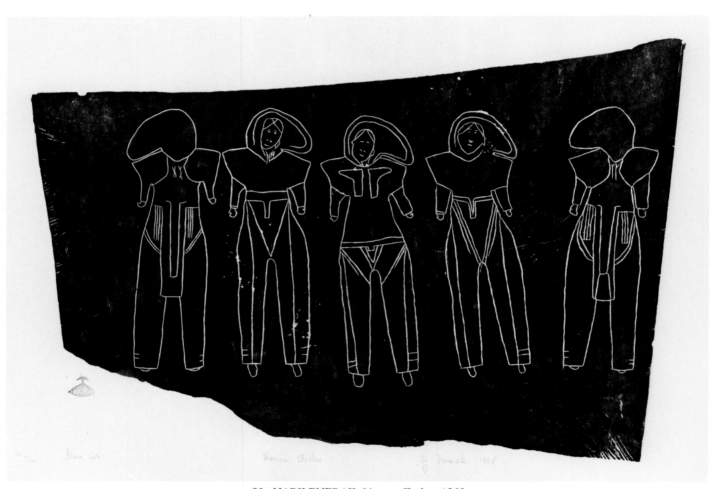

80. MARK EMERAK, *Women Clothes,* 1968

75. MARIE ARVIQTALIK, *Drum Dance,* no date

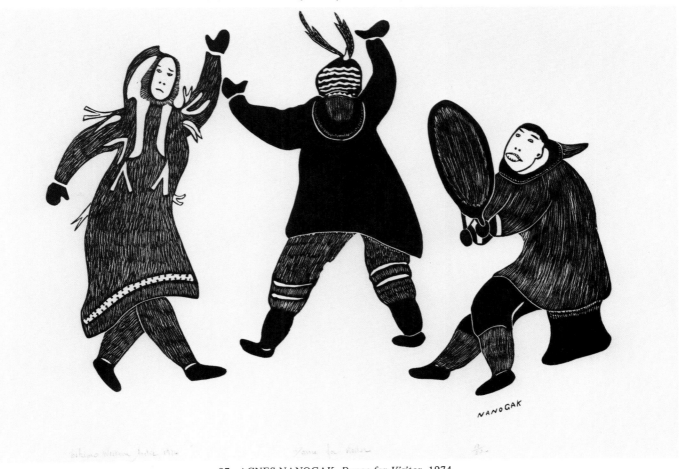

87. AGNES NANOGAK, *Dance for Visitor,* 1974

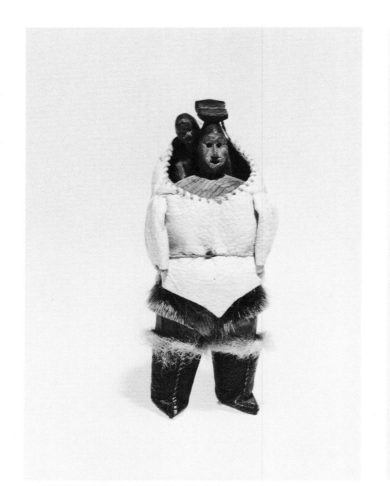

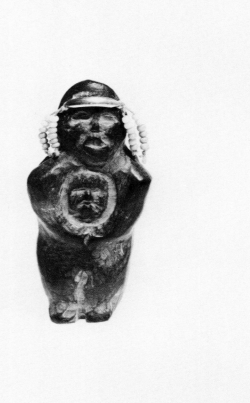

61. UNIDENTIFIED ARTIST (GREENLAND), *Woman with Child,* no date

23. MARY IQAAT, *Woman with Beads,* 1979

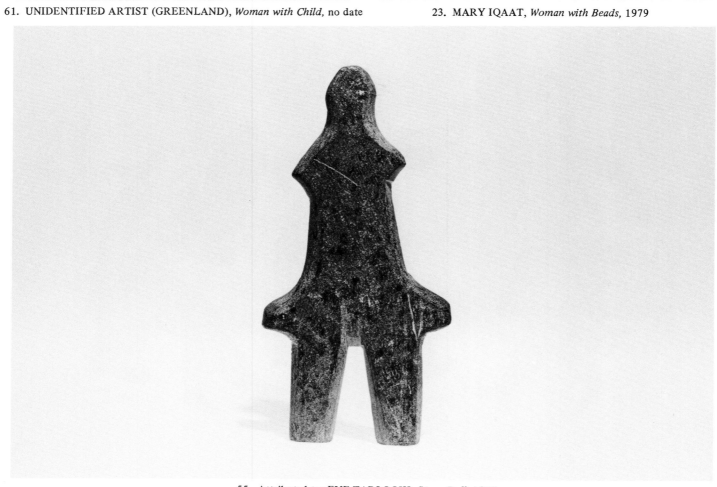

55. Attributed to: EVE TARLOOKI, *Stone Doll,* 1966

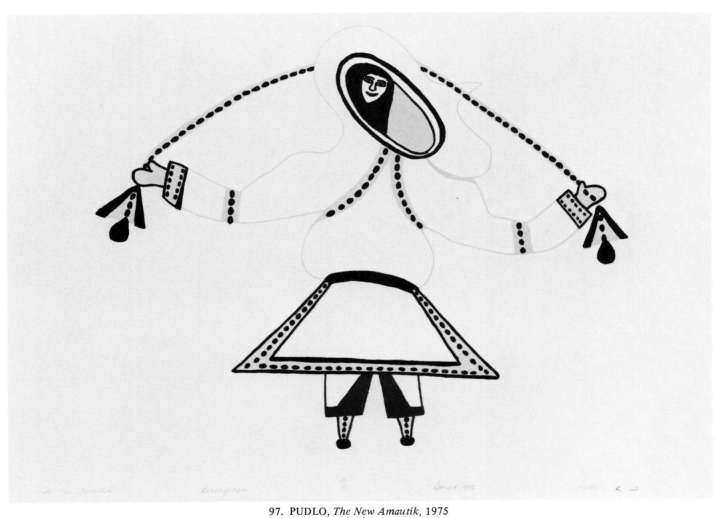

97. PUDLO, *The New Amautik,* 1975

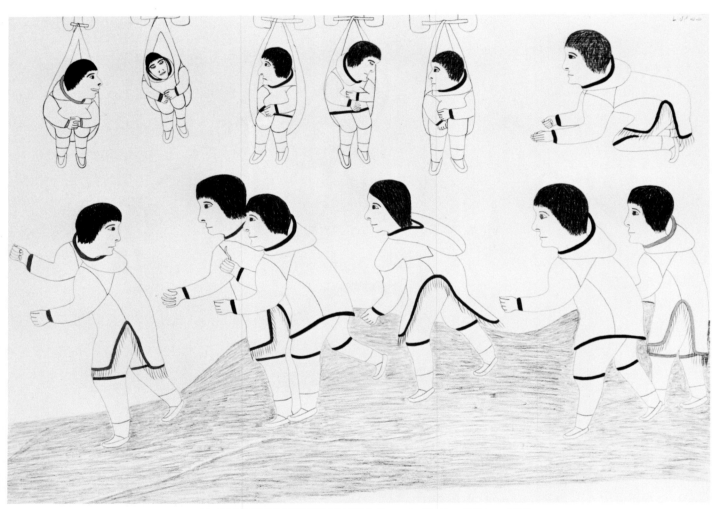

85. VICTORIA MUMNGSHOALUK, *Legend of Indian Children*, 1973

The Amautik as Baby Carrier

The *amautik*, with its large hood, carrying pouch, and generous size, is ideally equipped as a baby carrier. The *amaut* provides both security and independence to the child riding behind. The belt (*qassungati*) worn around the woman's body secures the placement of the child within the *amaut* and controls the size of the pouch. The belt is also important for the comfort of the mother; by attaching it at the neck of the parka and lacing it behind and under the *amaut*, it counter-balances the weight of the child and the corresponding pull against the throat.

A close bond is developed between mother and child as the two live in intimate union within the *amautik*. The generous size of the parka provides freedom of movement to both mother and child. When the child is hungry, the child may be passed from the *amaut* to the breast without leaving the warmth of the mother's parka (62). Moreover, the mother's senses are finely tuned to the emotional and physiological needs of the child. She is aware, through the slight and involuntary movements of the child on her back, when the child's bladder is full.[3] *Mother and Child* (29), by John Kaunak of Repulse Bay, is a particularly humourous treatment of this subject. The wailing youngster and the shocked face of the mother, with her left arm slipped under the *amautik*, appear to suggest a breakdown in communication. In *Mother and Son* (56), by George Tatanniq of Baker Lake, a child is held in front of the woman, within the *amautik*, in order to relieve himself. The correlation in image between the exposed phallus of the child and the *kiniq* of the mother's parka is particularly striking.

In direct contrast to the Inuit *amautik*, is the *tikonagan*, or baby carrier of neighboring Indian groups. In the *tikonagan*, the child is carried on the mother's back but in a separate wooden frame carrier. The *Legend of Indian Children* (85), by Mumngshoaluk, refers to a legend in which Inuit are said to have visited an Indian encampment. The adults have left the site for the day, leaving behind their children hung in these "strange contraptions".

There is an interesting comparison to be made between the Indian and Inuit means of carrying infants. In the early weeks of an infant's life, the hip capsule and ligaments securing the hip joint are lax, and the hip itself may be unstable and dislocatable. Carried in the *tikonagan*, an infant's legs are held in an extended position. This extension, which does not reinforce the proper positioning of the hip joint, appears to contribute to the instability and potential dislocation of the hip joint. In the *amautik*, the legs of an infant are bent in a frog-like fashion, or are wrapped around the mother's waist. The flexed position of the legs holds the head of the femur securely within the hip socket, promoting the proper growth and functioning of the hip joint.[4]

The closeness between mother and child, nurtured within the embracing form of the *amautik*, contributes to the intimacy of the Inuit family unit. This theme is present in the work of many Inuit artists. In *Family* (43), by Miriam Nanurluk, all eight figures are carved from the same stone, emphasizing the integration of the family group. The dominance of the mother is shown by her portrayal as the largest figure in the sculpture; she carries the smallest youngster in an *amaut* on her back. The arms of two of the youngsters rest on the heads of the brother or sister beside them, re-emphasizing the closeness of the family. In *Mother with Children* (42), a carving by the same artist, the half-grown figures of the children are attached to the mother's body, and appear to grow out of her sides. In the carving by Eda Kingilik (36), the mother, characterized by the large hood of the *amautik*, supports a load of three children piled piggy-back on her shoulders. The carving by Simeonie (52), shows a mother and two small children on her back. One, carried within the *amaut*, is bottle-fed by the second who stands on his mother's shoulder. The bent figures of the women in both carvings seem to allude to the weight of domestic and maternal responsibilities and perhaps as well, to the demographic realities faced by a society in which survival is no longer determined by natural forces beyond its control.

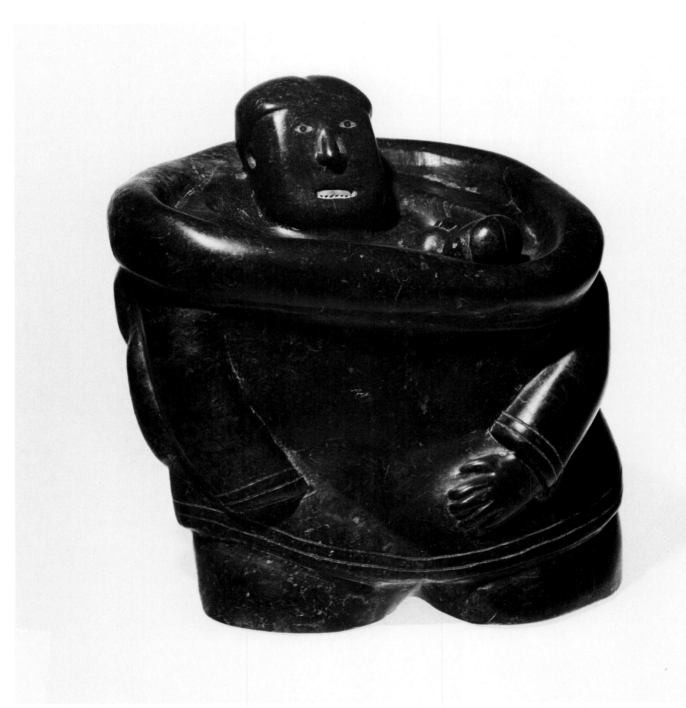

62. UNIDENTIFIED ARTIST (PORT HARRISON), *Mother Nursing Child,* c. 1955

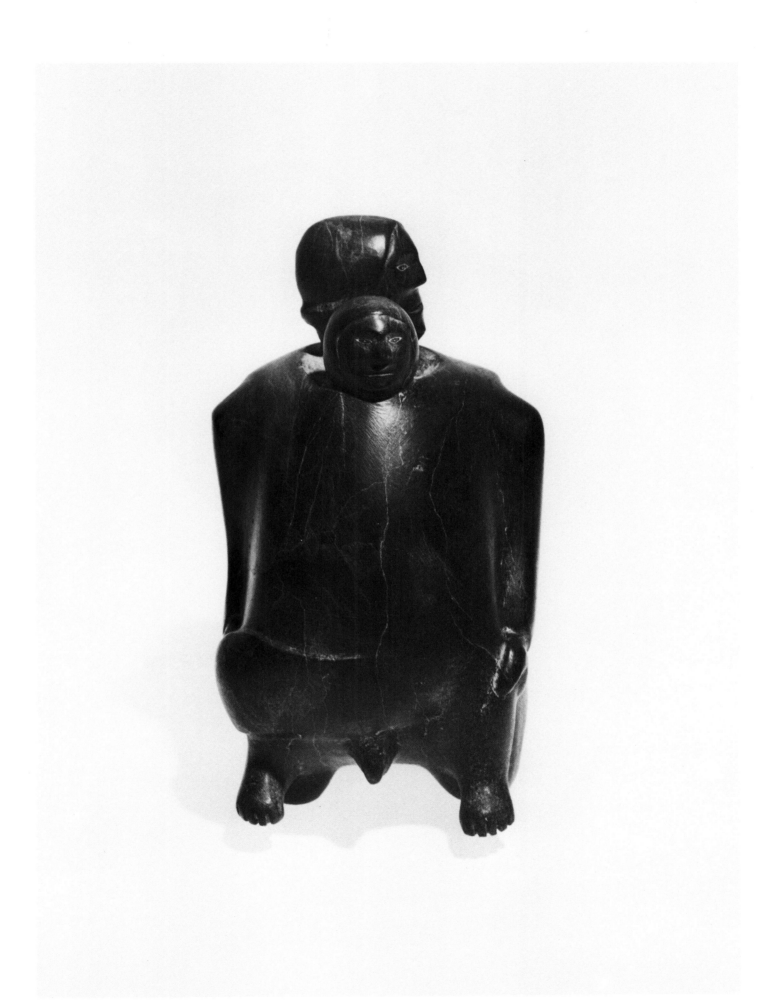

56. GEORGE TATANNIQ, *Mother and Son*, 1970

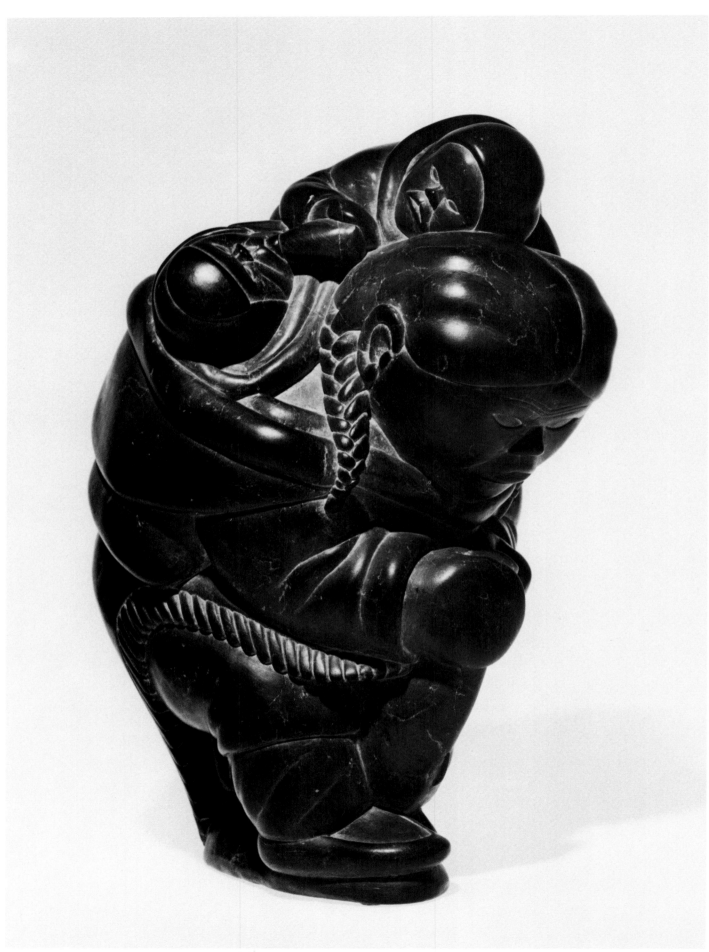

52. SIMEONIE, *Mother with Two Small Children*, no date

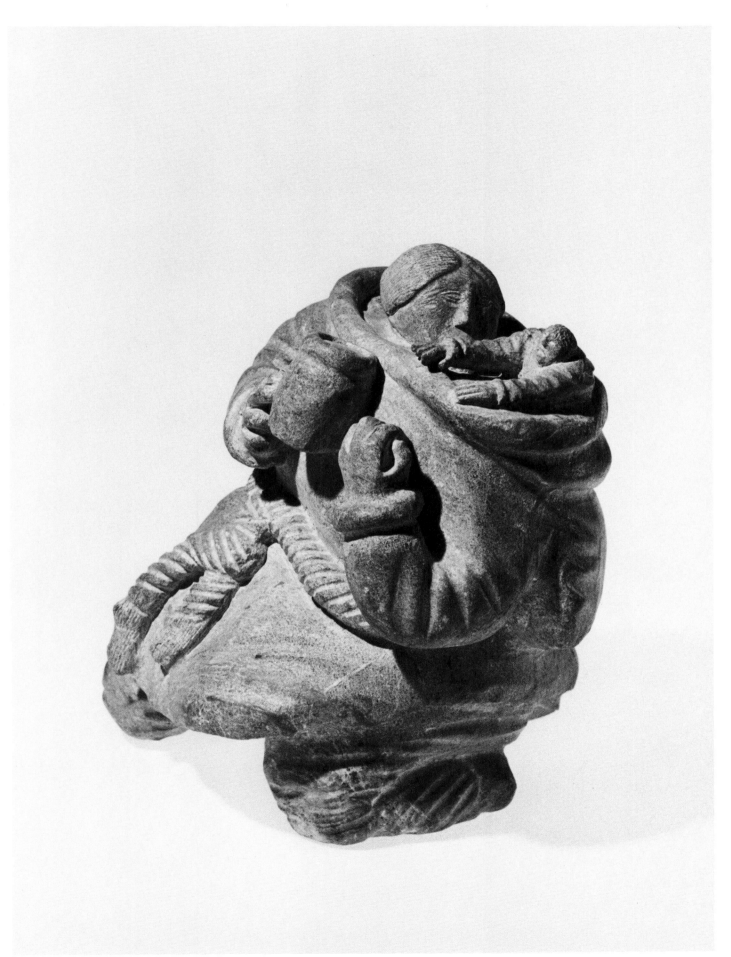

22. TIVI ILISITUK, *Mother with Child*, c. 1960

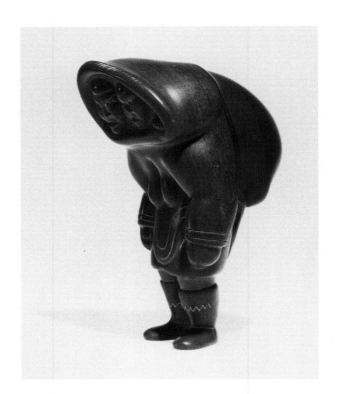

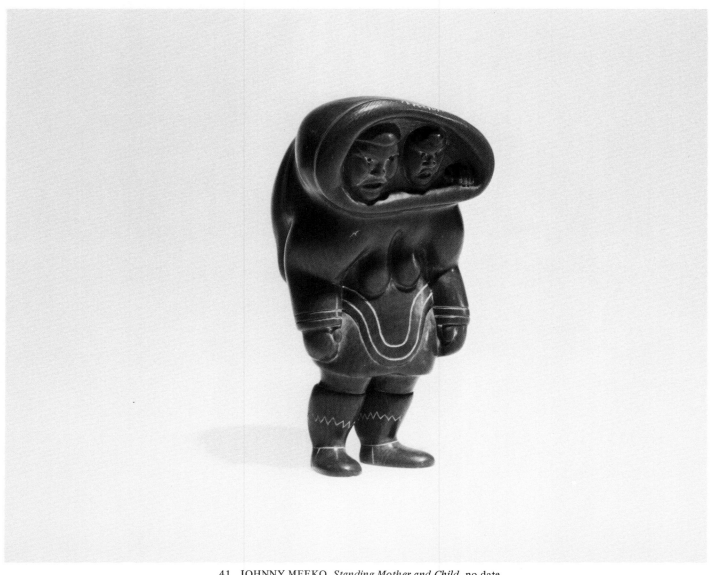

41. JOHNNY MEEKO, *Standing Mother and Child,* no date

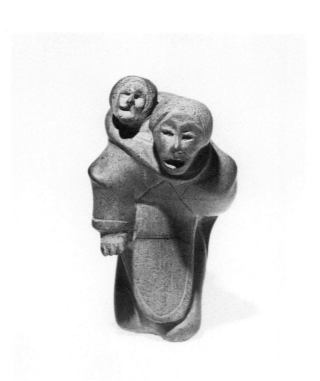

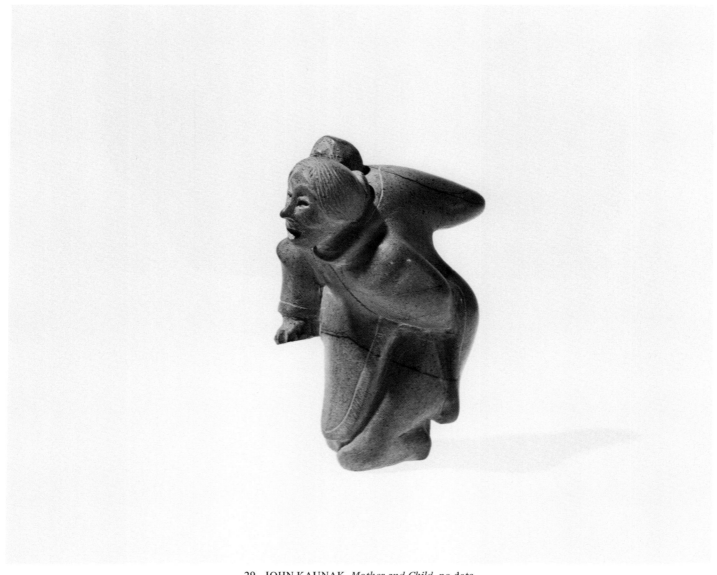

29. JOHN KAUNAK, *Mother and Child*, no date

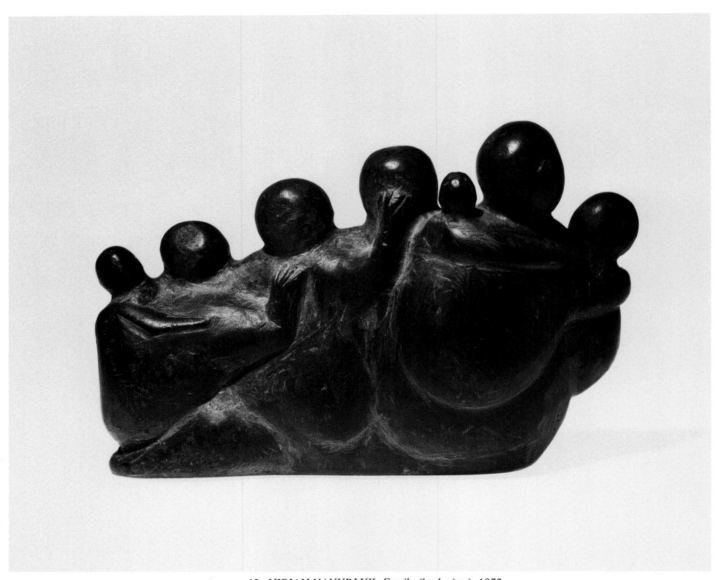

43. MIRIAM NANURLUK, *Family* (back view), 1972

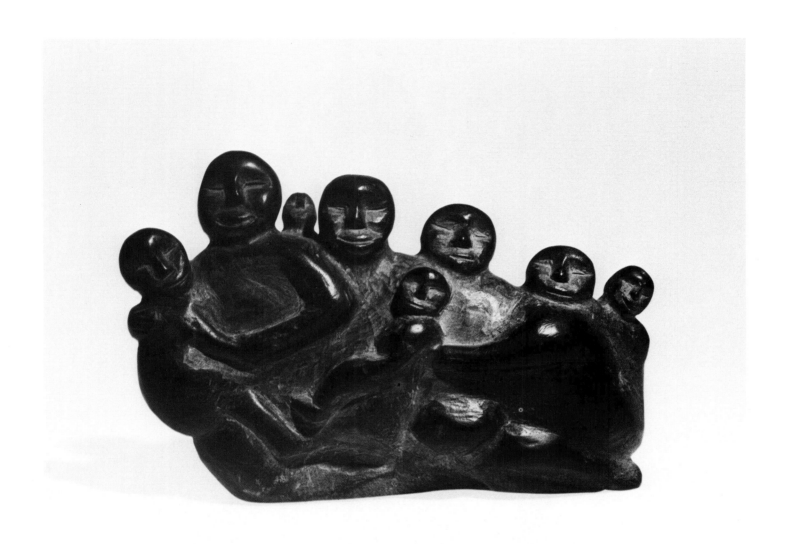

43. MIRIAM NANURLUK, *Family*, 1972

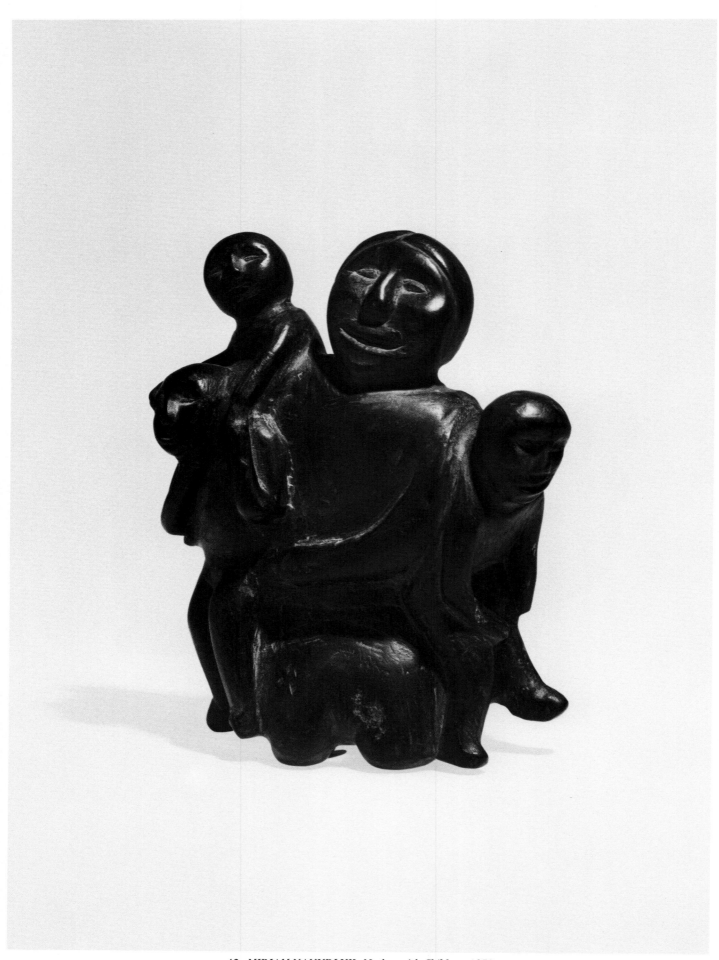

42. MIRIAM NANURLUK, *Mother with Children*, 1973

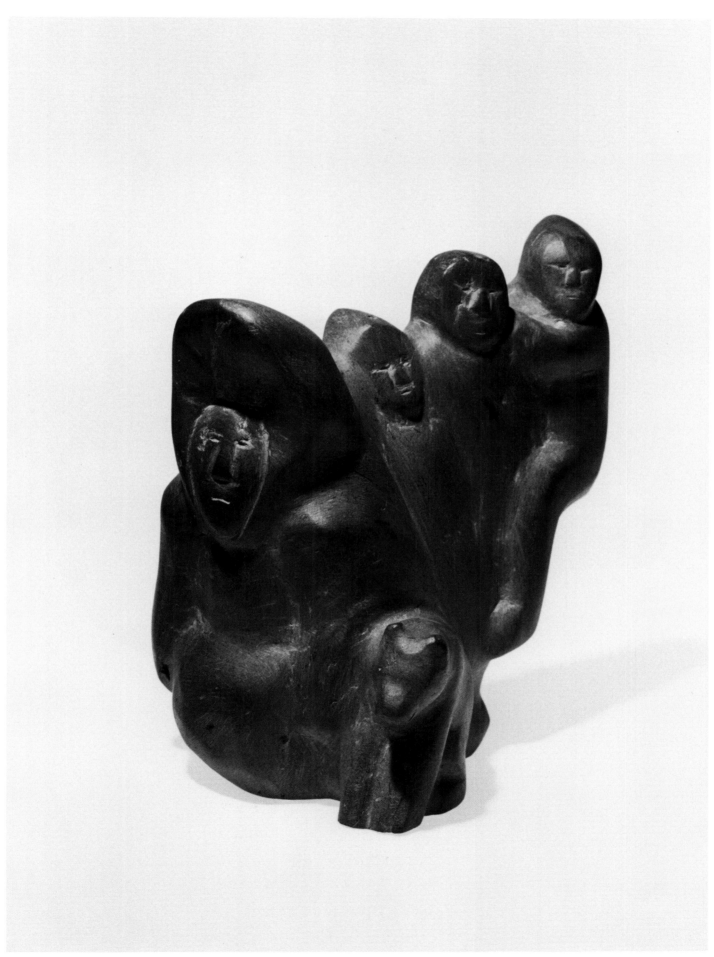

36. EDA KINGILIK, *Woman with Children and Pup*, 1974

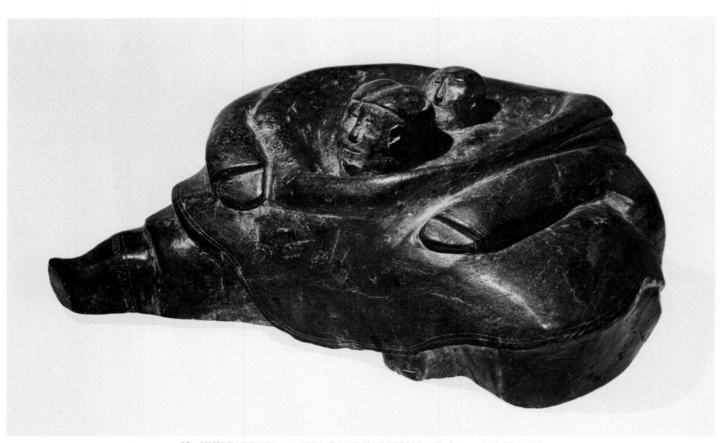

63. UNIDENTIFIED ARTIST (PORT HARRISON), *Mother and Child,* 1953

The Amautik as Form

The significance of the *amautik* in Inuit society, as well as the soft, rounded shape and generous proportion of the mother's parka, has encouraged its development as a formal convention in Inuit art. In the work of an unidentified artist from Port Harrison (63), the sunken hood of the *amautik* creates a special environment for mother and child. Both are shielded from the outside world by the corpulence of the mother's body and the exaggerated size of the *amautik*. The sculpture portrays the *amautik* as the extrauterine form it is, enveloping and protecting the child during the early years of life. In the sculpture by Annie Niviaxie (48), the fluid lines of the *amautik* surround mother and child. The rounded contours of the sculpture are re-emphasized in the placement of the mother's arms around the body of the child held before her, as well as in the positioning of the child's own arms. In the carving by Johnassie Mannuk (40), the head of the woman "floats" in the hood of the *amautik*. Could the artist's deliberate exaggeration of the hood be a reference to the solitude of the woman and the absence of a child within the *amaut*? In Figures 16 and 21, rather than portraying the full, robust images of mother and child usually created by the *amautik*, the figures of mother and child are static and rendered in a flat, elongated manner, as if to belie their three-dimensional form.

In a number of recent works, the artist's realistic portrayal gives way to an abstract expression of the *amautik* (31) and, more specifically, of the symbiotic union between mother and child (12, 15, 17). In this regard, the carving by Mamak of Baker Lake (39), creates a compelling and quintessential image. It is a precise expression of content through sculptural form, which in its purity and simplicity is reminiscent of *The Kiss* by Brancusi.

The concept of *amariik*, that is, the familiar silhouette of two heads which seem to emerge from the same body, may in itself serve as a source for a unique convention in Inuit art, that of multiple head images. *Family Group* by Luke Anautalik of Eskimo Point (11), shows a figure with four heads mounted totem-style, one upon the other; the last head is obviously that of a child carried in the *amaut*. The sculpture by David Tiktaalaaq of Baker Lake (59) uses a variation of the *amariik* convention, showing two heads supported on the shoulders of a base figure; a second view of the same work shows an additional pair of heads carved across the back of the supporting figure. Could this also be a family portrait, each member of the family remembered in infancy, being carried on the back of the mother? Could the *amariik* convention serve imagistically as well as conceptually as a source for the multiple head motif in Inuit art?[5]

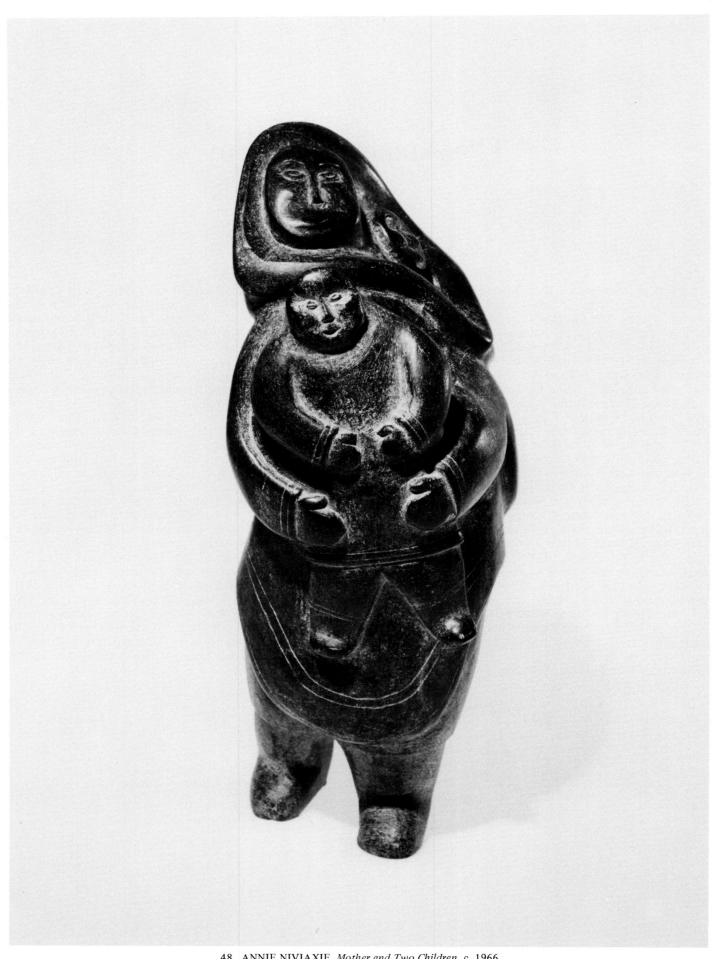

48. ANNIE NIVIAXIE, *Mother and Two Children*, c. 1966

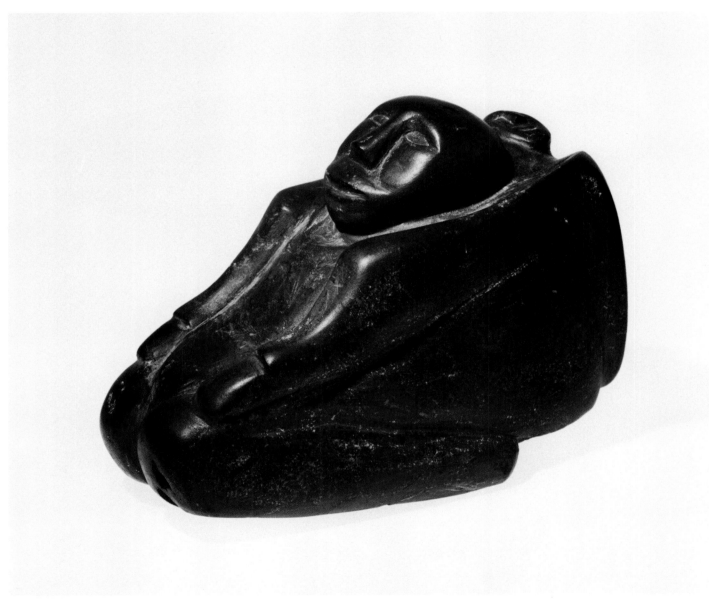

50. SILAS QIYUK, *Kneeling Woman and Child*, 1973

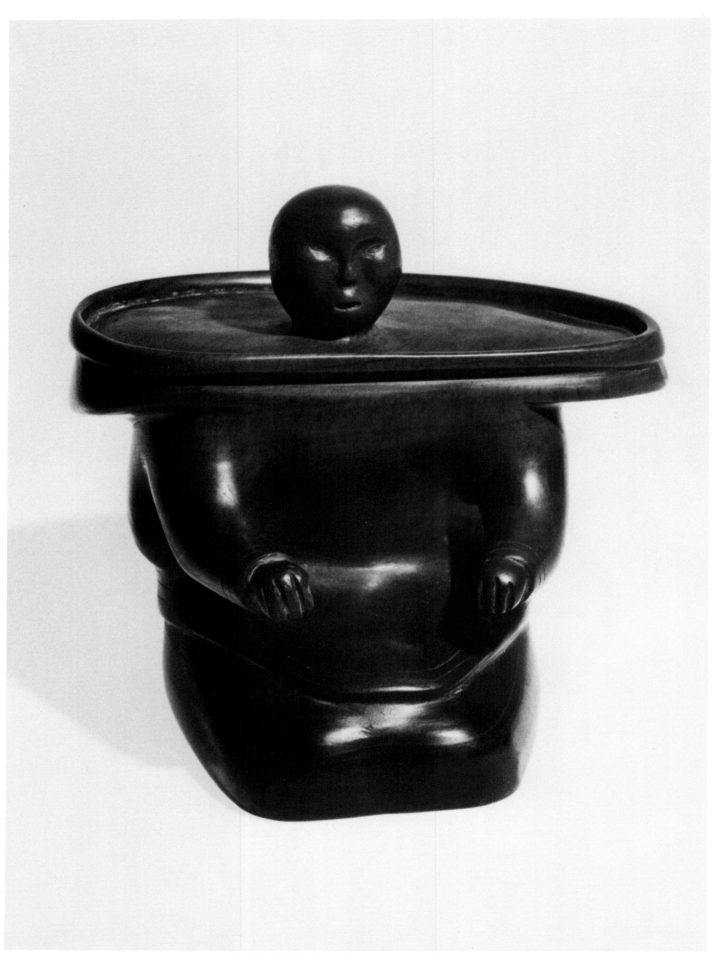

40. JOHNASSIE MANNUK, *Woman*, c. 1965

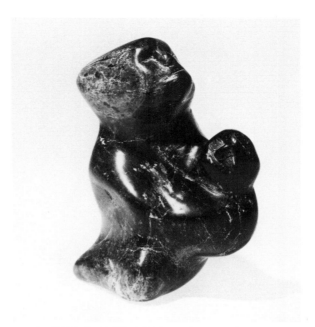

15. CECILE ANGMADLOK, *Mother and Child,* 1972

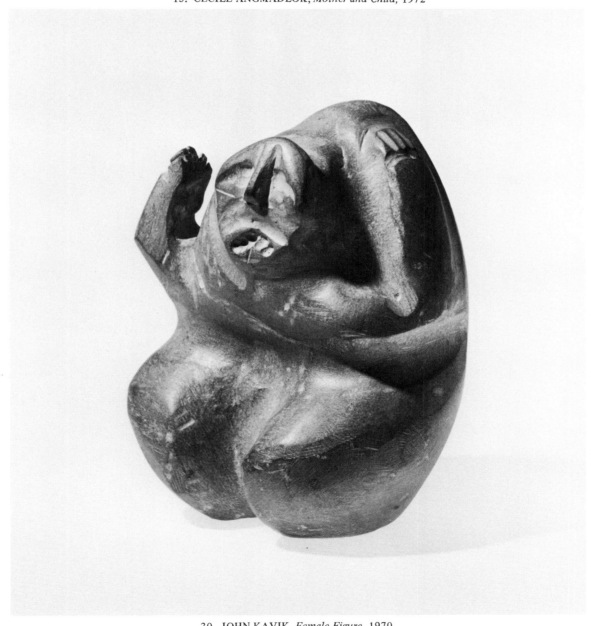

30. JOHN KAVIK, *Female Figure,* 1970

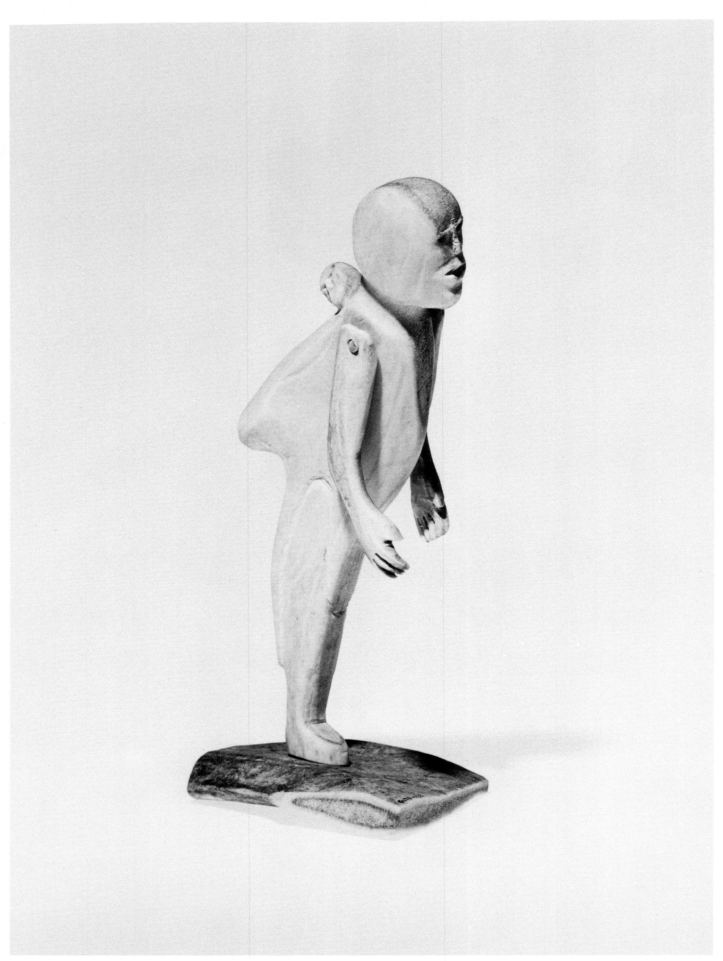

21. LUKE IKSIKTAARYUK, *Mother with Child*, 1970

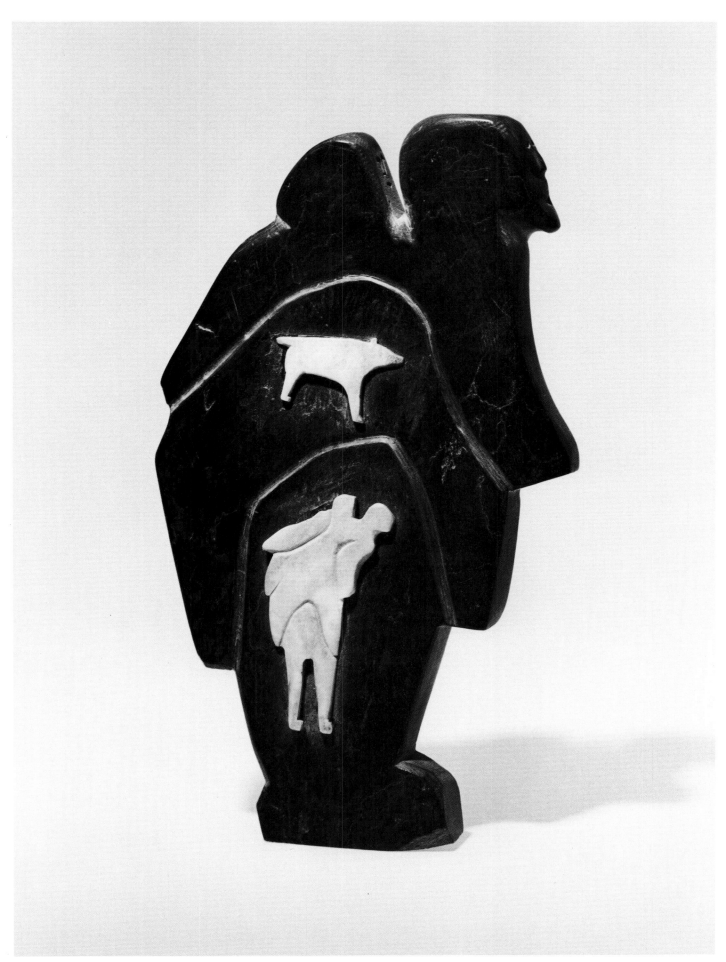

16. THOMAS ARNAYUINAK, *Woman and Child with Appliqué Figures*, 1968

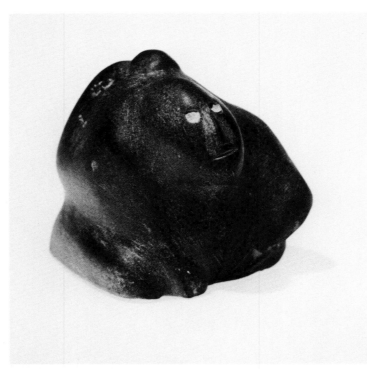

17. JOHN ATOK, *Woman and Child*, 1970

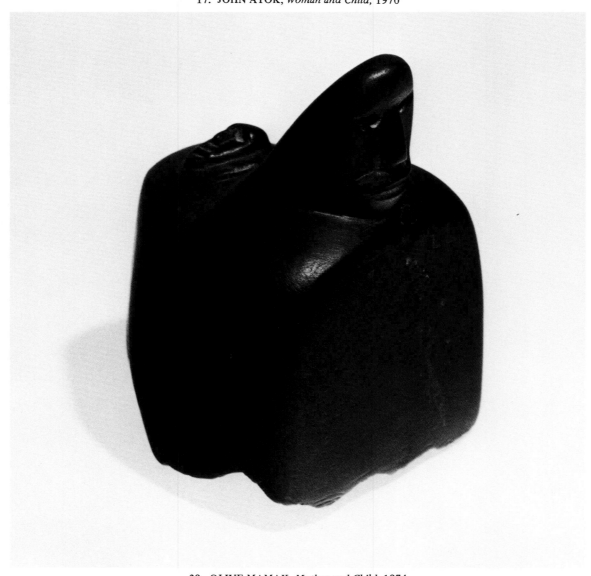

39. OLIVE MAMAK, *Mother and Child*, 1974

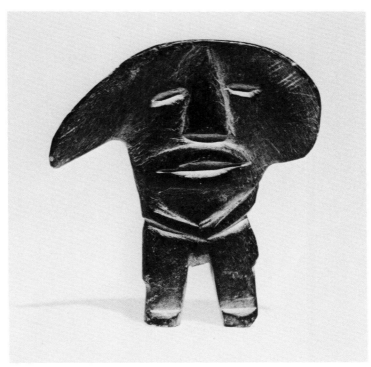

31. JOHN KAVIK, *Parka Image*, 1964

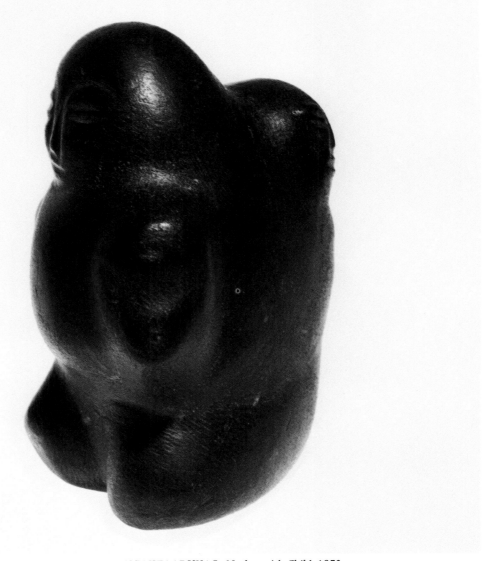

12. JOSEPH ANGAKTAARYUAQ, *Mother with Child*, 1973

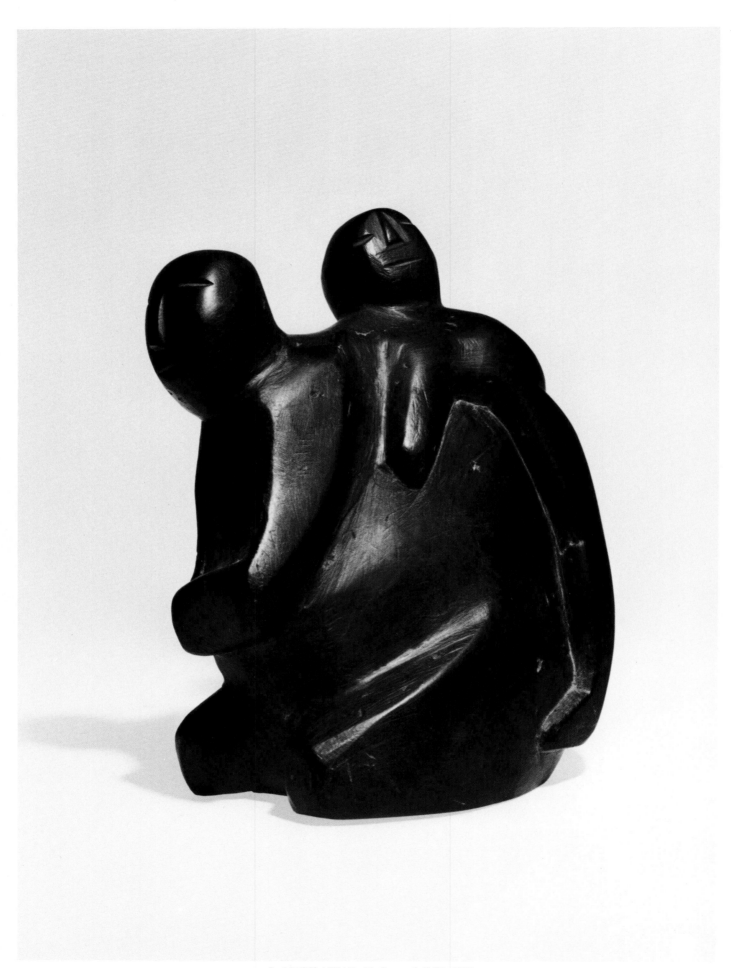

8. MARY AKJAR, *Mother and Child,* 1973

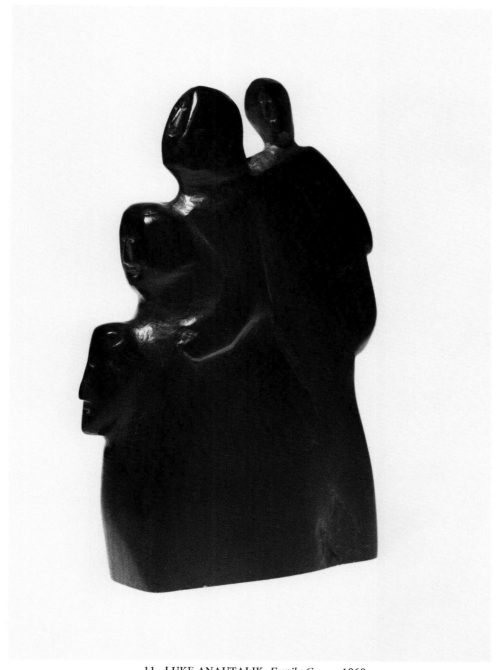

11. LUKE ANAUTALIK, *Family Group*, 1968

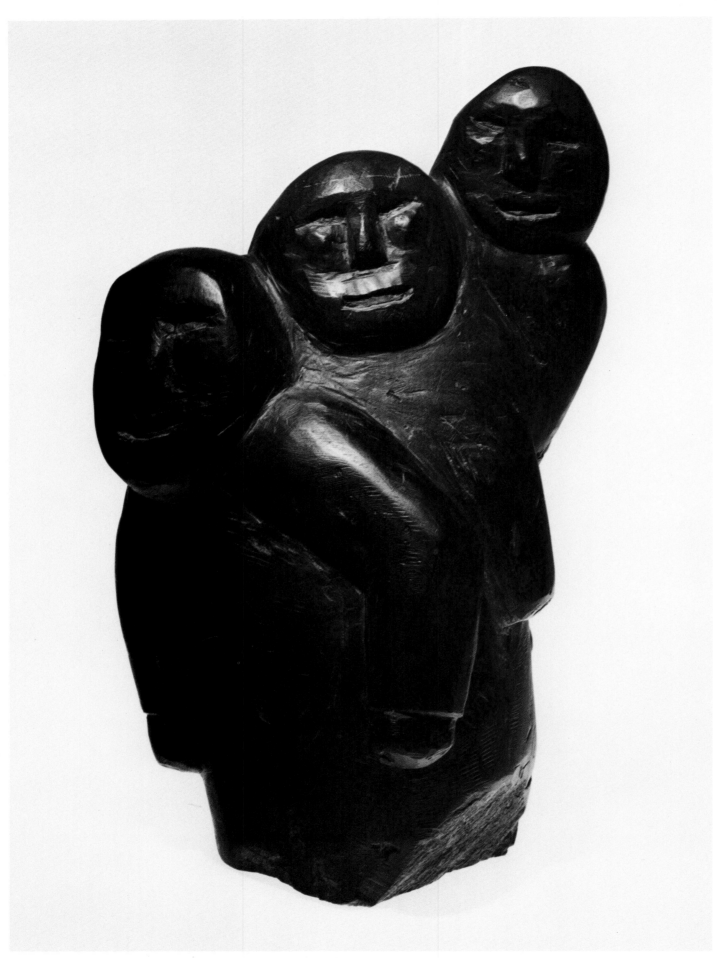

59. DAVID TIKTAALAAQ, *Three Figures,* no date

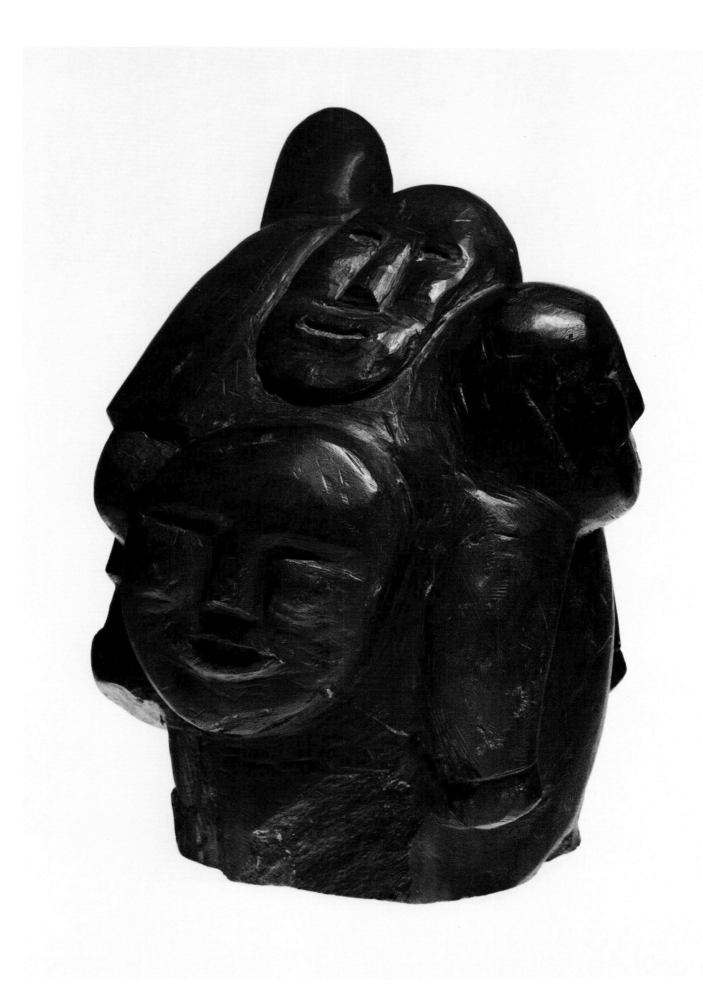

59. DAVID TIKTAALAAQ, *Three Figures* (back view), no date

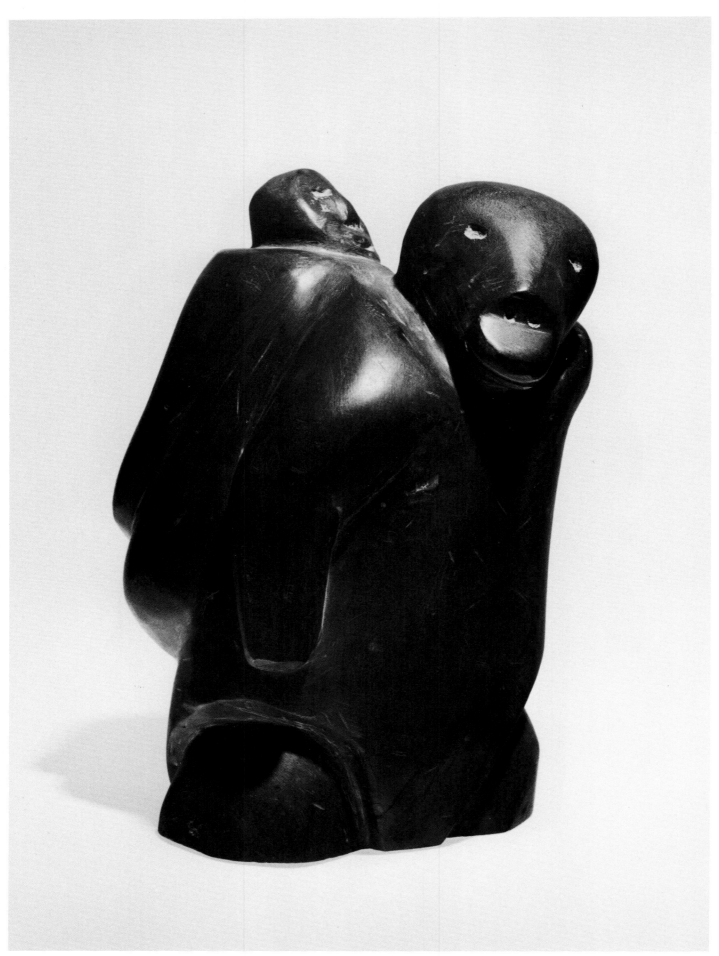

58. DAVID TIKTAALAAQ, *Untitled*, 1972

The Amautik as Concept

The rendering of the *amautik* in Inuit art is not limited to the realistic portrayal of mother and child. Occasionally the artist exploits the concept of the *amautik* to create surprising or unusual relationships between two natural or supernatural beings. In an untitled work by David Tiktaalaaq (58), the artist shows a bear figure dressed in the *amautik*, carrying a child on its back, while the carving by Thomas Sivuraq (54) shows a caribou calf carried in a young girl's *amaut*. In the carving by Naralik (45), a spirit head (*tunga*) appears to be riding on the back of a human, or more likely, on the back of another spirit being. The square cut of the *akuq* and the absence of any reference to the *kiniq* suggests that the figure is male rather than female.

The image of the *amautik* is also used by Inuit artists to suggest the anthropomorphic characteristics of mythological creatures. In a 1968 print by Davidialu (67), the artist uses the *amautik* to illustrate the supernatural transformation of a woman into a seagull. In the print, *Keeveeok's Family* (86), by Mumngshoaluk, the *amautik* is used to suggest the female attributes of the bird figure which Keeveeok, a popular figure in Inuit mythology, has taken for his wife.

The transition between human and animal is a common theme in Inuit cosmology, and frequently surfaces in Inuit art. In *Drawing for Contacting Spirits* (74), the two female shamans have been transformed into their helping spirits as they exercise their shamanic skills.

In the print by Mary Ashoona (76), Taleelayo, the guardian spirit of the sea, is shown dressed in an *amautik*. Although originally human, Taleelayo lives at the bottom of the sea and controls the supply of sea life to the Inuit. It is from her severed fingers that the sea animals, on which the Inuit rely, have sprung. This depiction of Taleelayo in an *amautik*, the Inuit symbol of life and regeneration, emphasizes her role as the genesis of sea-life.

In his text, *The Great Mother: A Study of an Archetype,* Neumann stresses that the maternal archetype and its expression in art contains both positive and negative elements: that is, the female is not only depicted as life-giving, but also as death-bringing. The image of Taleelayo (or "Nuliajuk" as she is known among the Netsilingmiut) incorporates both elements. Although she brings food to the Inuit, she may also, in a fit of anger or revenge, withhold her bounty from the people, allowing starvation and death to overtake the community. In the legend of *Amautilik*, the *amautik* becomes a symbol of death. *Amautilik* is the wretched woman who travels from camp to camp kidnapping young children and hiding them in the *amaut*. In the drawing of *Amautilik*, by Ruth Annaqtuusi (73), the artist presents an x-ray vision of the *amautik*, showing the children captured within the *amaut*.

In the prints by Oonark (91) and Anguhadluq (72), each artist assigns attributes of the woman — the *amautik*, tatooing, and hairsticks — to natural forces in the environment, suggesting, perhaps, an association between the life-giving forces of nature and the woman herself as the ultimate symbol of life.

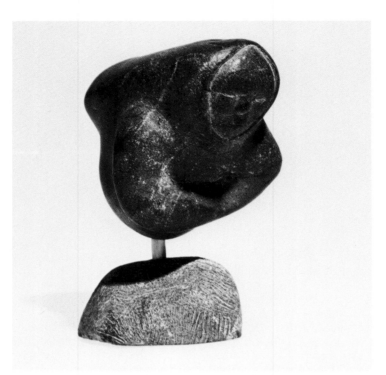

35. DOMINIC KINGILIK, *Bird-Woman: Soul Flight,* 1971

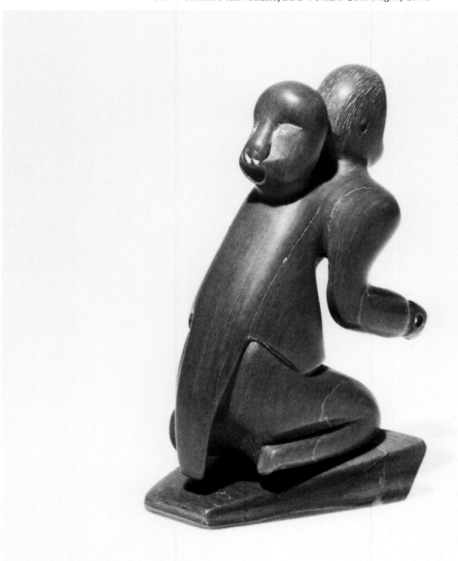

45. TIMOTHY NARALIK, *Figure with Tunga (Evil Spirit),* c. 1966

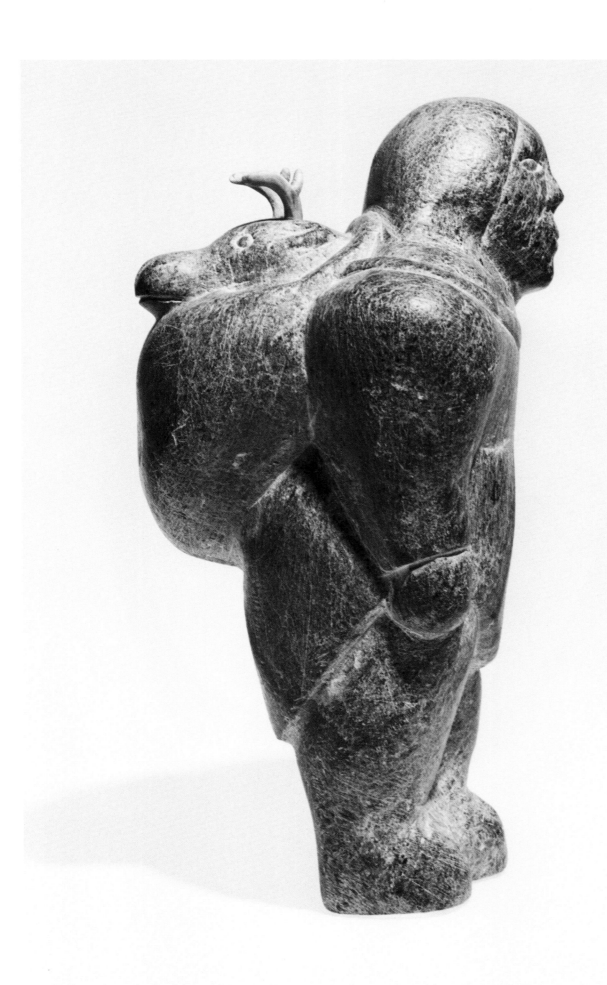

54. THOMAS SIVURAQ, *Caribou in Amautik*, 1978

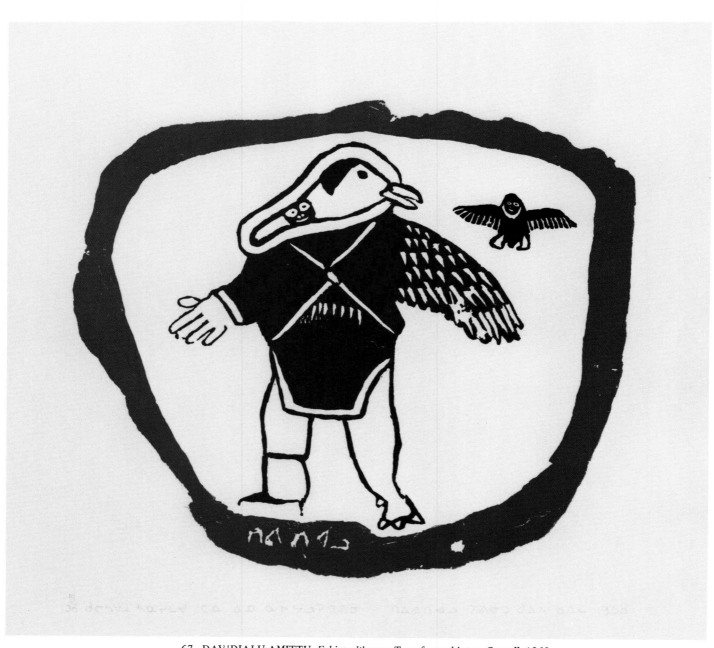

67. DAVIDIALU AMITTU, *Eskimo Woman Transformed into a Seagull*, 1968

Keeveok's Family 1/p V 1970 Mumookshoaluk, Mary Protok

86. VICTORIA MUMNGSHOALUK/WINNIE PUTUK, *Keeveeok's Family,* 1970

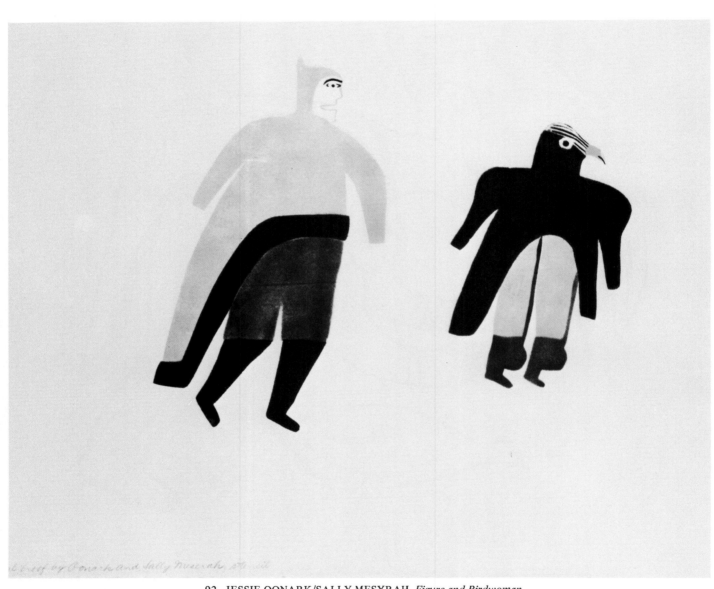

92. JESSIE OONARK/SALLY MESYRAH, *Figure and Birdwoman*

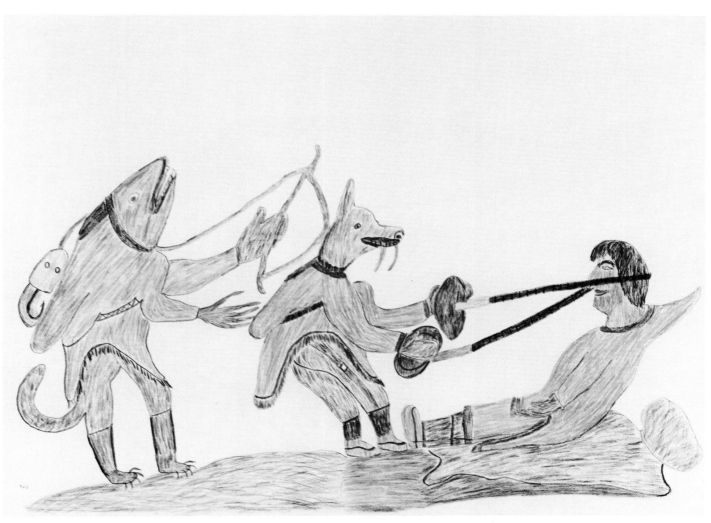

74. RUTH ANNAQTUUSI, *Drawing for Contacting Spirits,* 1977

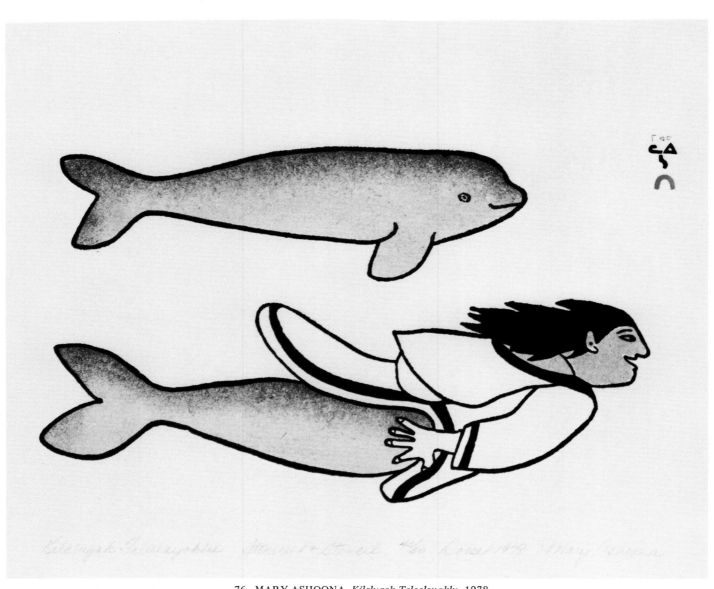

76. MARY ASHOONA, *Kilalugak Taleelayoklu*, 1978

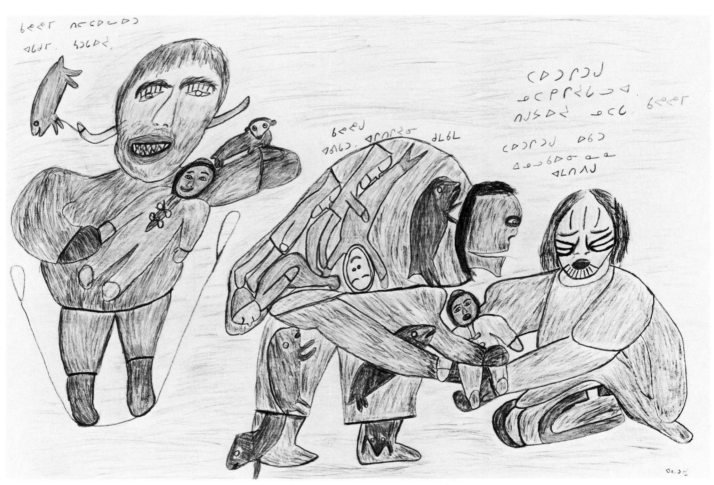

73. RUTH ANNAQTUUSI, *Legend of Amautilik*, 1972

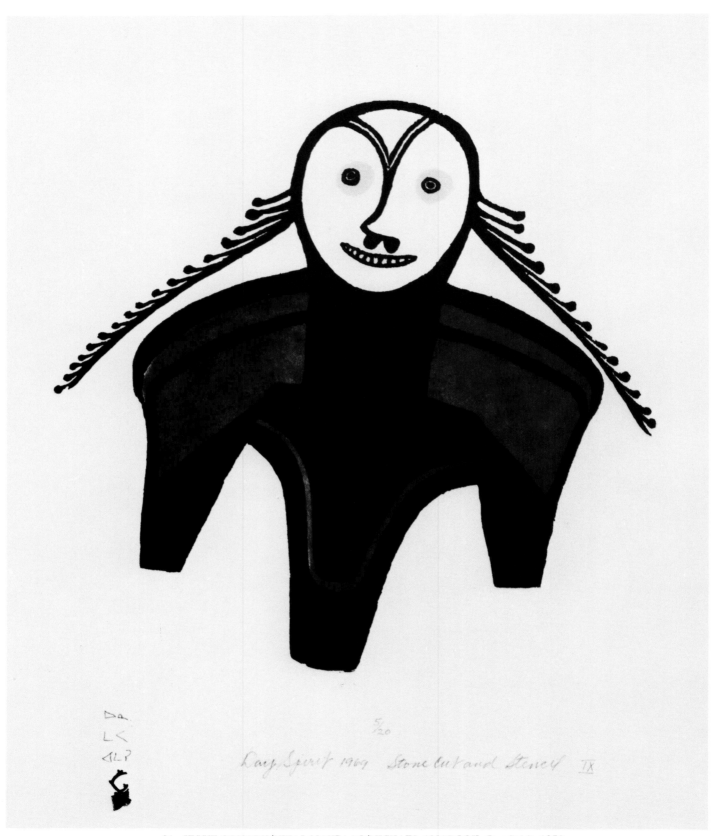

91. JESSIE OONARK/VITAL MAKPAAQ/MICHAEL AMAROOK, *Day Spirit,* 1970

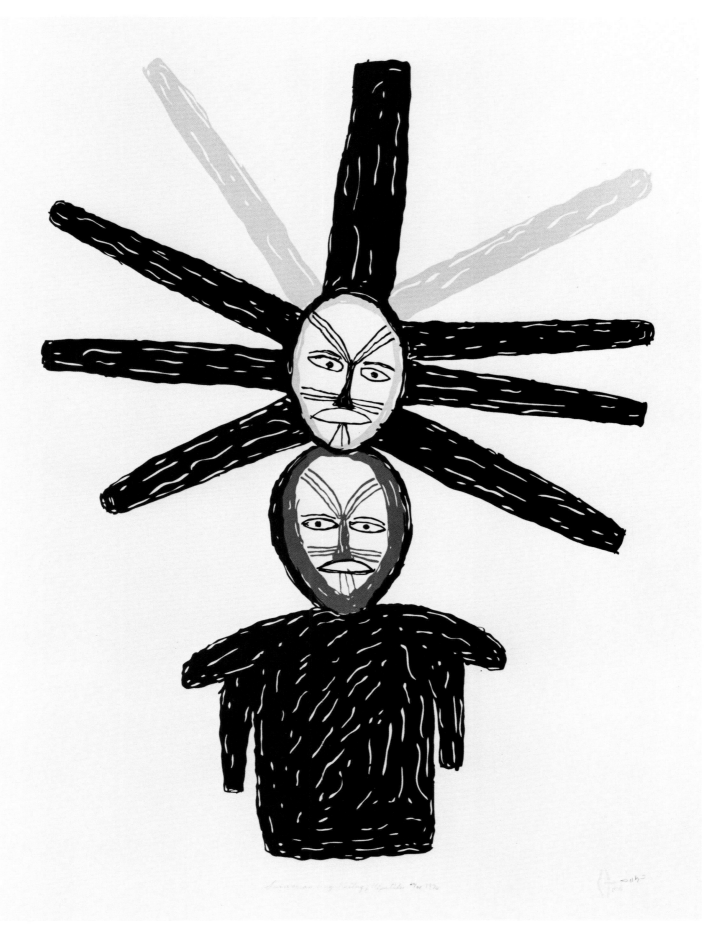

72. LUKE ANGUHADLUQ/WILLIAM UKPATIKU, *Sunwoman*, 1976

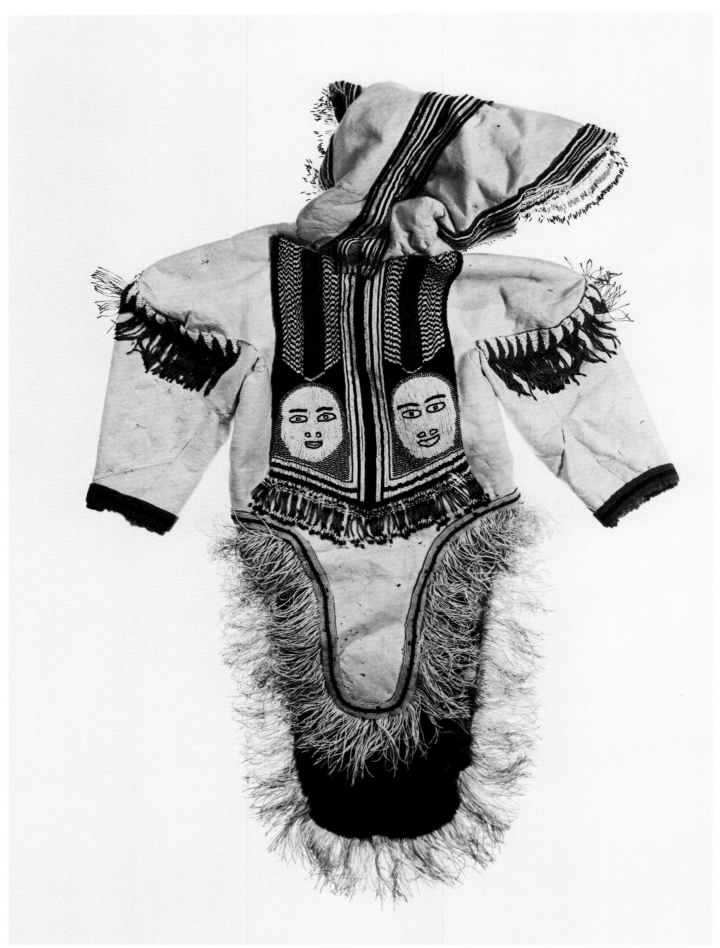

5. Adult woman's beaded *atigi,* made by Marion Tuu'luq, Baker Lake, 1971.

GLOSSARY

akukittut Canadian Inuit name for Greenlanders referring to tiny "tail" (*akuq*) on the Greenland parkas

akuq "tail" extending from the back of the parka

amaut carrying pouch on woman's parka

amautik (pl. amautiit) woman's parka with carrying pouch

angijurtaujuq the "new" amautik; evenly hemmed mother's parka

atigi inner layer of parka

igloqatiga housemate

inuk (pl. inuit) human (pl. the people; the human ones)

inuttitut the Inuit language

inuksuk (pl. inuksuit) rocks piled in figure-like shapes

kaliku ankle-length dress with outer covering of calico; also known as "Mother Hubbard"

kinerservik snowhut for childbirth

kiniq front flap on woman's parka

nasaq hood

parka Aleutian term meaning "fur jacket with hood"

pukiq white fur from caribou underbelly

qablunaat white people

qassungauti belt strap used around *amautik* to keep infant from slipping from pouch

qauruti headband of leather, copper, or brass worn by women

qulittaq outer layer of parka

saa front of parka

tikonagan Ojibway term for wooden frame baby carrier

tudlik stick used ornamentally in woman's hair

tunu back of parka

CATALOGUE
OF THE EXHIBITION

Works from The Winnipeg Art Gallery Collections are abbreviated as follows:

BB Bessie Bulman Collection
Donated by the Heirs of the Bessie Bulman Estate

GS The (George) Swinton Collection

JT Jerry Twomey Collection — with appreciation to the Province of Manitoba and the Government of Canada

WAG The Winnipeg Art Gallery Permanent Collection

SJZ Collection of Stanley and Jean Zazelenchuk, on loan to The Winnipeg Art Gallery.

Measurements are in centimeters in the following order: height, width, depth.

Dates are given only for those works for which there is a recorded date.

AMAUTIIT

The following caribou women's parkas are on loan for this exhibition from The Bishop Marsh Inuit Collection, The Manitoba Museum of Man and Nature (1 through 4); and, on long-term loan to The Winnipeg Art Gallery, from the private collection of Mr. and Mrs. K. J. Butler (5):

1. CHILD'S QULITTAQ
 Collected in 1938, Eskimo Point
 Central Eastern Inuit: Caribou
 Length of back, neck to *akuq:* 62.0
 Length of front, neck to *kiniq:* 63.0
 Width of shoulders: 61.0
 Length of hood: 26.0
 (H5.21.122) 241.80

2. YOUNG WOMAN'S QULITTAQ
 Collected in 1938, Eskimo Point
 Central Eastern Inuit: Padlimiut
 Length of back, neck to *akuq:* 99.0
 Length of front, neck to *kiniq:* 70.5
 Width of shoulders: 61.0
 Length of hood: 48.0
 (H5.21.121) 242.80

3. YOUNG WOMAN'S QULITTAQ
 Collected in 1938, exact location unknown
 Central Eastern Inuit: Ivelik
 Length of back, neck to *akuq:* 108.0
 Length of front, neck to *kiniq:* 78.0
 Width of shoulders: 67.0
 Length of hood: 52.0
 (H5.21.294) 243.80

4. ADULT WOMAN'S BEADED ATIGI
 Collected in 1937, exact location unknown
 Central Eastern Inuit: Padlimiut
 Length of back, neck to *akuq:* 99.0
 Length of front, neck to *kiniq:* 67.5
 Width of shoulders: 63.0
 Length of hood: 55.0
 (H5.21.25) 244.80

5. ADULT WOMAN'S BEADED ATIGI
 Made in 1971, by Marion Tuu'luq, Baker Lake
 Central Eastern Inuit
 Length of back, neck to *akuq:* 116.0
 Length of front, neck to *kiniq:* 88.0
 Width of shoulders: 84.0
 Length of hood: 69.0
 835.76

SCULPTURE

AKEEAKTASHUK (1898-1954)
PORT HARRISON / INOUCDJOUAC

6. MOTHER AND CHILD, 1953
 dark green stone and ivory
 18.0 x 12.4 x 14.7
 WAG
 Donated by the Women's Committee
 G-60-51

7. MOTHER AND CHILD, 1953
 grey/brown/black stone
 18.7 x 13.5 x 6.6
 GS
 G-76-381

AKJAR ANAUTALIK, MARY (b. 1938)
ESKIMO POINT

8. MOTHER AND CHILD, 1973
 black stone
 19.7 x 15.9 x 10.5
 SJZ
 1245.75

ALASUA, AISA QUPIRUALA (b. 1916)
POVUNGNITUK

9. CROUCHING MOTHER AND CHILD, c. 1953
 grey-green marbled stone, ivory, black inset
 13.3 x 13.3 x 18.1
 WAG
 Donated by the Women's Committee
 G-60-52

AMITTU, DAVIDIALU ALASUA (1910-1976)
POVUNGNITUK

10. MOTHER NURSING CHILD, 1959
 grey stone
 6.4 x 24.6 x 20.5
 GS
 G-76-397

ANAUTALIK, LUKE (b. 1923)
ESKIMO POINT

11. FAMILY GROUP, 1968
 black stone
 14.3 x 3.1 x 10.1
 GS
 G-76-213

ANGAKTAARYUAQ, JOSEPH (1935-1976)
BAKER LAKE

12. MOTHER WITH CHILD, 1973
 black stone
 15.2 x 9.8 x 10.4
 SJZ
 980.75

ANGITOOKALOOK, DANIEL (b. 1908)
GREAT WHALE RIVER

13. MOTHER AND CHILD
 dark grey stone
 21.1 x 13.0 x 8.8
 JT
 1613.71

ANGMADLOK ANGUTIALUK, CECILE (b. 1938)
REPULSE BAY

14. WOMAN, 1972
 dark green stone
 11.2 x 7.0 x 7.5
 GS
 G-76-492

15. MOTHER AND CHILD, 1972
 black/green stone
 14.0 x 6.6 x 10.7
 GS
 G-76-561

ARNAYUINAK, THOMAS (b. 1931)
ESKIMO POINT

16. WOMAN AND CHILD WITH APPLIQUE FIGURES, 1968
 black/green stone and antler
 24.1 x 14.0 x 2.8
 GS
 G-76-155

ATOK, JOHN (b. 1906)
ESKIMO POINT

17. WOMAN AND CHILD, 1970
 dark grey stone
 6.8 x 6.3 x 8.4
 GS
 G-76-176

EKALUN, PATRICK (b. 1905)
BATHURST INLET

18. MAN DRAGGING WOMAN
 green stone
 9.4 x 3.7 x 12.6
 JT
 821.71

ENNUTSIAK (1896-1967)
FROBISHER BAY

19. MOTHER, CHILDREN AND PUP, 1966
 grey stone
 11.4 x 11.1 x 10.8
 BB
 G-72-92

20. MIDWIVES AND BABY, 1965
 grey stone
 8.9 x 14.0 x 17.8
 BB
 G-72-142

IKSIKTAARYUK, LUKE (1909-1977)
BAKER LAKE

21. MOTHER WITH CHILD, 1970
 antler
 23.5 x 8.6 x 13.1
 GS
 G-76-25

ILISITUK, TIVI (TUULDAQ) (b. 1933)
SUGLUK

22. MOTHER AND CHILD, c. 1960
 grey stone
 23.9 x 23.2 x 19.1
 WAG
 Donated by the Women's Committee
 G-60-26

IQAAT, MARY (QAIQSAUT) (b. 1935)
BAKER LAKE

23. WOMAN WITH BEADS, 1979
 stone, beads, metal, sinew
 6.6 x 3.3 x 3.0
 The Upstairs Gallery, Winnipeg
 248.80

IQULIK, TOONA (b. 1935)
BAKER LAKE

24. WOMAN GIVING BIRTH, 1963
 black stone
 32.0 x 26.5 x 21.5
 GS
 G-76-40

25. PREGNANT WOMAN KNEELING
 chlorite stone (black)
 44.4 x 46.0 x 32.0
 From the collection of
 Their Excellencies, the Right
 Honourable Edward R. Schreyer and
 Lily Schreyer,
 Governor General of Canada, on loan to
 The Winnipeg Art Gallery
 1809.72

IRQIQUQ SORUSILUK, MARY (b. 1897)
SUGLUK

26. MOTHER HOLDING CHILD, 1953
 black/green/brown stone
 20.2 x 10.4 x 16.7
 GS
 G-76-630

ITUVIK, MAGGIE (b. 1898)
SUGLUK

27. WOMAN HOLDING CHILD, c. 1963
 grey stone
 24.8 x 12.4 x 11.6
 JT
 3973.71

KASUDLUAK, ISA (b. 1917)
PORT HARRISON / INOUCDJOUAC

28. MAN AND WOMAN, 1961
 green stone
 8.9 x 12.1 x 3.8
 BB
 G-72-201

KAUNAK, JOHN (b. 1941)
REPULSE BAY

29. MOTHER AND CHILD
 grey stone
 12.1 x 6.6 x 9.8
 JT
 3094.71

KAVIK, JOHN (b. 1897)
RANKIN INLET

30. FEMALE FIGURE, 1970
 grey stone
 17.4 x 14.2 x 12.3
 GS
 G-76-449

31. PARKA IMAGE, 1964
 black/grey stone
 9.6 x 8.5 x 2.4
 GS
 G-76-450

KAVIK, JOHNASSIE (b. 1916)
BELCHER ISLANDS

32. CRAWLING WOMAN WITH CHILD,
 1964
 green/black stone
 8.5 x 13.3 x 17.4
 JT
 892.71

33. WOMAN COOKING, 1964
 green/black stone
 13.4 x 10.3 x 17.4
 JT
 894.71

KIATAINAQ, TOKAK (b. 1935)
WAKEHAM BAY

34. WOMAN WITH CHILD USING ULU,
 1961
 black/grey with red stone
 13.5 x 8.4 x 16.3
 GS
 G-76-642

KINGILIK, DOMINIC (b. 1939)
BAKER LAKE

35. BIRD-WOMAN: SOUL FLIGHT, 1971
 green stone and bone
 16.0 x 9.5 x 13.6
 GS
 G-76-71

KINGILIK IYI'TUAQ, EDA (b. 1934)
BAKER LAKE

36. WOMAN WITH CHILDREN AND PUP,
 1974
 grey stone
 20.0 x 19.7 x 12.7
 SJZ
 1038.75

LEW, LOOTEE (b. 1947)
ARCTIC BAY

37. WOMAN AND MAN, 1963
 blue-grey with orange stone
 11.1 x 4.6 x 4.2
 BB
 G-72-192

LUKASI, MIAIJI UITANGI (MARY)
(b. 1911)
SUGLUK

38. SEATED MOTHER HOLDING CHILD,
 c. 1959
 grey stone
 14.6 x 12.7 x 9.5
 WAG
 Donated by the Women's Committee
 G-60-50

MAMAK, OLIVE (b. 1915)
BAKER LAKE

39. MOTHER AND CHILD, 1974
 black stone
 12.3 x 8.9 x 9.5
 SJZ
 1061.75

MANNUK, JOHNASSIE (b. 1929)
BELCHER ISLANDS

40. WOMAN, c. 1965
 green/black stone
 12.8 x 14.3 x 14.7
 GS
 G-76-86

MEEKO, JOHNNY (b. 1933)
BELCHER ISLANDS

41. STANDING MOTHER AND CHILD
 green stone
 14.5 x 8.1 x 9.8
 JT
 921.71

NANURLUK, MIRIAM (b. 1933)
BAKER LAKE

42. MOTHER WITH CHILDREN, 1973
 black stone
 18.4 x 14.6 x 7.6
 SJZ
 1075.75

43. FAMILY, 1972
 grey stone
 14.0 x 20.7 x 7.4
 SJZ
 1077.75

NARALIK, TIMOTHY (b. 1942)
BELCHER ISLANDS

44. WOMAN WITH LAMP, BOOTS AND
 BOX, 1968
 green stone and black stone
 12.0 x 13.0 x 10.8
 SJZ
 1221.75

45. FIGURE WITH TUNGA (EVIL SPIRIT)
 c. 1966
 green stone
 12.0 x 5.7 x 8.0
 BB
 G-72-81

NAYOUMEALOOK (1891-1966)
PORT HARRISON / INOUCDJOUAC

46. WOMAN STRETCHING AND
 SHAPING BOOT, c. 1962
 dark green stone
 22.0 x 18.5 x 13.8
 JT
 1826.71

NEEOOKTOOK, IRENEE (b. 1937)
BAKER LAKE

47. STANDING WOMAN, c. 1967
 black stone
 24.1 x 12.2 x 17.6
 JT
 666.71

NIVIAXIE, ANNIE (b. 1930)
GREAT WHALE RIVER

48. MOTHER AND TWO CHILDREN,
 c. 1966
 grey stone
 25.9 x 10.5 x 15.6
 JT
 1627.71

QIYUK, SILAS (b. 1933)
BAKER LAKE

49. MOTHER WITH CHILD, 1974
 black stone
 21.6 x 23.5 x 15.9
 SJZ
 1103.75

50. KNEELING WOMAN AND CHILD,
 1973
 grey stone
 21.0 x 14.2 x 27.5
 SJZ
 2162.75

SAVIADYUK, MARY (b. 1897)
SUGLUK

51. MOTHER AND CHILD
 grey stone
 28.5 x 9.5 x 19.2
 JT
 3960.71

SIMEONIE (b. 1941)
PORT HARRISON

52. WOMAN WITH TWO SMALL
 CHILDREN
 grey-black stone
 28.3 x 18.0 x 21.3
 Dr. Otto Schaefer, Edmonton
 251.80

SIVURAQ, PETER (b. 1940)
BAKER LAKE

53. STANDING WOMAN, 1971
 black stone
 17.8 x 14.6 x 11.4
 SJZ
 1108.75

SIVURAQ, THOMAS (b. 1941)
BAKER LAKE

54. CARIBOU IN AMAUTIK, 1978
 stone and bone
 22.5 x 12.0 x 11.1
 The Upstairs Gallery, Winnipeg
 247.80

ATTRIBUTED TO:
TARLOOKI ALIKTILUK, EVE
(b. 1927)
ESKIMO POINT

55. STONE DOLL, 1966
 grey/brown stone
 13.0 x 6.3 x 1.4
 GS
 G-76-235

TATANNIQ, GEORGE (b. 1910)
BAKER LAKE

56. MOTHER AND SON, 1970
 black/green stone
 18.2 x 10.7 x 14.8
 GS
 G-76-74

57. WOMAN, 1973
 grey-green stone
 35.0 x 25.0 x 20.0
 SJZ
 1132.75

TIKTAALAAQ, DAVID (b. 1927)
BAKER LAKE

58. UNTITLED, 1972
grey stone
22.5 x 15.5 x 15.0
SJZ
1145.75

59. THREE FIGURES
grey stone
32.8 x 24.5 x 15.0
SJZ
1146.75

USUITUAYUK, LUKASSIE (b. 1899)
SUGLUK

60. MOTHER HOLDING CHILD, 1954
brown/black stone
19.0 x 9.8 x 15.5
GS
G-76-633

UNIDENTIFIED ARTISTS

GREENLAND

61. WOMAN WITH CHILD
wood, skin, fur
10.1 x 4.1 x 4.9
JT
4118.71

PORT HARRISON / INOUCDJOUAC

62. MOTHER NURSING CHILD, c. 1955
dark green/light green stone, ivory,
soap inlay
26.7 x 26.7 x 20.4
WAG
Donated by the Women's Committee
G-60-40

63. MOTHER AND CHILD, 1953
grey stone
18.1 x 42.2 x 29.7
WAG
Donated by the Women's Committee
G-60-66

64. IGLOO WITH POT, OIL LAMP AND
CUP, c. 1955
stone, ivory and sinew
22.9 x 32.9 x 13.7
JT
1917.71

65. WOMAN, c. 1955
dark green stone, bone and hide
18.5 x 13.3 x 17.2
JT
1931.71

SUGLUK

66. MOTHER AND CHILD AT PLAY,
1955
grey stone
22.2 x 11.4 x 10.8
WAG
Donated by the Women's Committee
G-60-53

PRINTS AND DRAWINGS

AMITTU, DAVIDIALU ALASUA
(1910-1976)
POVUNGNITUK

67. ESKIMO WOMAN TRANSFORMED
INTO A SEAGULL, 1968
stonecut
36.4 x 38.8
GS
G-76-786

ANGENIK
BAKER LAKE

68. BAKER LAKE COSTUMES, c. 1964
pencil and pen
24.1 x 20.3
GS
Donated by the Volunteer Committee
G-76-806

ANGUHADLUQ, LUKE (b. 1895)
BAKER LAKE

69. FAMILY WITH FISH CATCH, c. 1971
coloured pencil
51.0 x 66.0
SJZ
2085.75

70. DRUM DANCE, 1974
coloured pencil
56.7 x 76.0
SJZ
2093.75

71. WOMAN, c. 1970
pencil and coloured pencil
66.0 x 50.8
GS
Donated by the Volunteer Committee
G-76-876

ANGUHADLUQ, LUKE (b. 1895)
/ UKPATIKU, WILLIAM (b. 1935)
BAKER LAKE

72. SUNWOMAN, 1976
silkscreen
76.2 x 55.9
WAG
G-76-936

ANNAQTUUSI, RUTH (b. 1934)
BAKER LAKE

73. LEGEND OF AMAUTILIK, 1972
coloured pencil and pencil
52.7 x 75.5
Mr. and Mrs. K. J. Butler, Winnipeg
90.78

74. DRAWING FOR CONTACTING
SPIRITS, 1977
coloured pencil
56.0 x 75.7
Sanavik Cooperative, Baker Lake
2898.77

ARVIQTALIK, MARIE (b. 1903)
BAKER LAKE

75. DRUM DANCE
coloured pencil
51.1 x 66.0
GS
Donated by the Volunteer Committee
G-76-877

ASHOONA, MARY (b. 1946)
CAPE DORSET

76. KILALUGAK TALEELAYOKLU,
1978
stonecut and stencil
35.5 x 45.8
WAG
Donated by The Winnipeg Art Gallery
Shop through the Volunteer Committee
G-80-54

EEGYVUDLUK (b. 1920)
CAPE DORSET

77. YOUNG GIRL'S PARKA, 1972
felt pen
27.9 x 21.6
Dorothy H. Eber, Montréal
238.80

78. WOMAN IN DECORATED AMAUTIK
(FRONT VIEW), 1972
felt pen
27.9 x 21.6
Dorothy H. Eber, Montreal
239.80

79. WOMAN IN DECORATED AMAUTIK
(BACK VIEW), 1972
felt pen
27.9 x 21.6
Dorothy H. Eber, Montréal
240.80

EMERAK, MARK (b. 1901)
HOLMAN ISLAND

80. WOMEN CLOTHES, 1968
stonecut
45.4 x 61.0
GS
G-76-765

IKSIKTAARYUK, LUKE (1909-1977)
/TIRIGANIAQ, JAMES (b. 1946)
/NOAH, MARTHA (b. 1943)
BAKER LAKE

81. AN ANCIENT WAY OF DANCING,
1971
stonecut and stencil
100.0 x 63.0
Sanavik Cooperative, Baker Lake
2712.77 A

ITTULAKATNAK, MARTHA (b. 1912)
/MAKPAAQ, VITAL (b. 1922)
BAKER LAKE

82. MOTHERS AND CHILDREN, 1971
stonecut
30.8 x 24.1
GS
G-76-812

KAGYUT, WILLIAM (b. 1922)
HOLMAN ISLAND

83. VENGEANCE FOR A WOMAN,
1966
stonecut
50.9 x 76.2
WAG
Donated by Mr. and Mrs. A. S. Leach, Jr.
G-78-4

KALVAK, HELEN (b. 1901)
HOLMAN ISLAND

84. BIRTH, 1977
lithograph
57.4 x 76.5
WAG
Donated by the Winnipeg Art Gallery
Shop
G-78-53

MUMNGSHOALUK, VICTORIA (b. 1930)
BAKER LAKE

85. LEGEND OF INDIAN CHILDREN,
1973
coloured pencil
56.0 x 76.5
SJZ
2040.75

MUMNGSHOALUK, VICTORIA (b. 1930)
/PUTUK, WINNIE (b. 1957)
BAKER LAKE

86. KEEVEEOK'S FAMILY, 1970
stonecut
53.6 x 43.7
Sanavik Cooperative, Baker Lake
2684.77 A

NANOGAK, AGNES (b. 1925)
HOLMAN ISLAND

87. DANCE FOR VISITOR, 1974
stonecut
45.8 x 61.4
SJZ
2004.75

OONARK (UNA), JESSIE (b. 1906)
(CAPE DORSET/KAZAN RIVER)

88. TATTOOED FACES, 1960
stonecut
60.5 x 31.1
WAG
Donated by the Women's Committee
G-61-1

89. INLAND ESKIMO WOMAN, 1960
stonecut
58.6 x 31.8
GS
G-76-778

OONARK, JESSIE (b. 1906)
/IKSIRAQ, THOMAS (b. 1941)
BAKER LAKE

90. THE PEOPLE WITHIN, 1970
stonecut
30.5 x 48.4
GS
G-76-842

OONARK, JESSIE (b. 1906)
/MAKPAAQ, VITAL (b. 1922)
/AMAROOK, MICHAEL (b. 1941)
BAKER LAKE

91. DAY SPIRIT, 1970
stonecut and stencil
54.6 x 41.9
WAG
Norman Powell Memorial Fund
G-70-600

OONARK, JESSIE (b. 1906)
/MESYRAH, SALLY (b. 1952)
BAKER LAKE

92. FIGURE AND BIRDWOMAN
stencil
42.8 x 61.9
GS
G-76-873

OONARK, JESSIE (b. 1906)
/NOAH, MARTHA (b. 1943)
BAKER LAKE

93. YOUNG WOMAN, 1972
stencil
32.6 x 51.0
GS
G-76-843

OONARK, JESSIE (b. 1906)
/THOMAS MANNIK (b. 1948)
BAKER LAKE

94. WOMAN, 1970
stonecut
79.1 x 55.2
WAG
Norman Powell Memorial Fund
G-70-602

PITSEOLAK (c. 1900)
CAPE DORSET

95. DREAM OF MOTHERHOOD, 1969
stonecut
61.4 x 87.5
WAG
Donated by the Women's Committee
G-69-64

96. WOMAN WITH GEESE, 1967
engraving
33.0 x 50.0
WAG
Donated by the Women's Committee
G-67-64

PUDLO (b. 1916)
CAPE DORSET

97. THE NEW AMAUTIK, 1975
lithograph
56.3 x 66.0
Fleet Gallery, Winnipeg
246.80

SOROSEELUTU (b. 1941)
CAPE DORSET

98. KALEVIKTUKTO, 1976
lithograph
28.0 x 33.4
Fleet Gallery, Winnipeg
245.80

ULAYU (b. 1904)
CAPE DORSET

99. WOMAN IN BEADED AMAUTIK,
1972
felt pen, ballpoint pen
27.9 x 21.6
Dorothy H. Eber, Montréal
237.80

PHOTOGRAPHS

100. PORTRAIT OF SHOOFLY COMER
[A.P. Low Expedition, 1903-04]
Public Archives Canada
PA - 53548

101. WOMEN IN BEADED ATIGIT
[A.P. Low Expedition, 1903-04]
Public Archives Canada
PA-53606

WALLHANGING

IKAHIK, MARTHA (b. 1912)
(EEKERKUK)
ESKIMO POINT

102. FIGURES IN BEADED PARKAS, 1978
duffle, beads, skin, and antler
146.0 x 42.5
Ian Lindsay, Ottawa
249.80

LENDERS

Mr. and Mrs. K. J. Butler, Winnipeg

Dorothy Eber, Montréal

Fleet Gallery, Winnipeg

Ian Lindsay, Ottawa

Manitoba Museum of Man and Nature, Winnipeg

Public Archives of Canada, Ottawa

Dr. Otto Schaefer, Edmonton

Their Excellencies, the Right Honourable Edward R. Schreyer
Governor General of Canada and Lily Schreyer

Upstairs Gallery, Winnipeg

Stanley and Jean Zazelenchuk, Rankin Inlet

Permission to reproduce the works illustrated in this catalogue has been obtained from Patrick Ekalun, Umingmaktuuq, N. W. T. (Bathurst Inlet), and from the following Cooperatives on behalf of the artists:

West Baffin Eskimo Cooperative, Cape Dorset, N. W. T.

Kooneak Eskimo Cooperative, Arctic Bay, N. W. T.

Sanavik Eskimo Cooperative, Baker Lake, N. W. T.

Metiq Eskimo Cooperative, Sanikiluaq, N. W. T. (Belcher Islands)

Padlei Eskimo Cooperative, Eskimo Point, N. W. T.

Ikaluit Eskimo Cooperative, Frobisher Bay, N. W. T.

La Fédération des coopératives du Nouveau Québec, Montréal, Qué. (on behalf of Great Whale River,
Port Harrison, Povungnituk, Sugluk, and Wakeham Bay)

Holman Eskimo Cooperative, Holman Island, N. W. T.

Kissarvik Eskimo Cooperative, Rankin Inlet, N. W. T.

Naujat Eskimo Cooperative, Repulse Bay, N. W. T.

NOTES

1. TURNER, 1894, p. 210.
2. MATHIASSEN, 1928, p. 181.
3. MURDOCH, 1892, p. 110.
4. cf. DRISCOLL: Illustrations from the records of early European explorers indicate that the long back panel was an original feature of both men's and women's parkas.
5. MELANIE TALVATAH, personal communication, Eskimo Point, 1978.
6. JENNESS, 1946, p. 12.
7. The function of the *kiniq* is also described as that of a windbreaker. (Pharand, 1975, p. 24)
8. RASMUSSEN, *Netsilik*, p. 258.
9. *Ibid.*
10. TAGGAK CURLEY, personal communication, 1979.
11. SCHNEIDER, 1970, p. 121; Father Schneider suggests that the term for the woman's *kiniq* is associated with the practice of holding the child in front of the *kiniq* to urinate.
12. George Swinton's intuition with regard to the symbolic content of the *kiniq* initiated this research into the linguistic associations of the term.
13. HATT, 1969, p. 31; PHARAND, 1975, p. 27.
14. JENNESS, 1946, p. 8.
15. The stripes of *pukiq* found at the wrist and shoulders of both men's and women's parkas might be interpreted as references to joint markings. (George Swinton, personal communication, 1978) The location of three stripes at the wrist on the Copper woman's parka could be read as "displaced" joint markings, referring to shoulder, elbow and wrist joints. (cf. Schuster, 1951)
16. The use of dehaired fringes on the caribou parka may be seen as a reference to the long-hair of the caribou fur. (George Swinton, personal communication, 1979)
17. HOLTVED, 1967, pp. 49-52.
18. ANDY AWA, personal communication, Igloolik, 1978.
19. HOLTVED, 1967; cf. DRISCOLL
20. PHARAND, 1975, p. 48.
21. *Ibid.*, pp. 20-22; MATHIASSEN, pp. 185-86.
22. LORRAINE FALCIONI, personal communication, Eskimo Point, 1978.
23. RASMUSSEN, *Netsilik,* p. 268.
24. *Ibid.*, p. 269.
25. *Ibid.,* p. 42.
26. *Ibid.,* p. 274.
27. RASMUSSEN, *Iglulik,* p. 155.
28. TURNER, 1894, pp. 211-212.
29. EBER, 1973, p. 37.
30. ROSS, 1975, p. 25.
31. cf. JOHNSON, 1979.
32. Hudson Bay Company Archives, A 28/20, folio 4, 1913.
33. MATHIASSEN, 1928, p. 177; I am grateful to Kate Duncan, formerly a Research Fellow at the Smithsonian Institution, Washington, D. C., for sharing with me portions of her own research on Athabaskan beadwork.
34. cf. DRISCOLL.
35. GEORGE SWINTON, personal communication, 1978.
36. cf. BLODGETT, 1976, unpaged.
37. TURNER, 1894, p. 208.
38. MATHIASSEN, 1928, p. 188.
39. RASMUSSEN, *Alaskan,* pp. 157-58.
40. BOAS, 1964, p. 220.
41. FATHER VAN DE VELDE, personal communication, Churchill, 1978.
42. RASMUSSEN, *Netsilik,* p. 140.
43. *Ibid.*: The Netsilingmiut explained to Rasmussen that a woman's next pregnancy was delayed until she had completed nursing her youngest child. Suppression of ovulation through lactation is the subject of a study carried out by Drs. J. Hildes and O. Schaefer — the results of which support the observation of Rasmussen's informers. (Hildes and Schaefer, 1973, pp. 245-46)
44. BIRKET-SMITH, *Caribou,* p. 287.
45. RASMUSSEN, *Netsilik,* p. 54.
46. BOAS, 1907, pp. 122-23.
47. RASMUSSEN, *Nitsilik,* p. 165.
48. BIRKET-SMITH, *Caribou,* p. 142; RASMUSSEN, *Netsilik,* p. 505.
49. RASMUSSEN, *Netsilik,* p. 215.
50. The *Report of the Fifth Thule Expedition* is the published account of a small team of Danish anthropologists, an archaeologist, and a naturalist who travelled across the Canadian Arctic and Alaska documenting the traditional life of Inuit groups they encounter.
51. PITSEOLAK, 1971, unpaged.

CHAPTER NOTES

1. GEORGE SWINTON, personal communication, 1978.
2. cf. BOAS, 1907, p. 509.
3. Schaefer, 1976, pp. 474-75.
4. Salter, 1968.
5. cf. BLODGETT, 1974.

BIBLIOGRAPHY

AMUNDSEN, ROALD
> *The North West Passage; Being the Record of a Voyage of Exploration of the Ship Gjöa* 1903-1907, London: Archibald Constable, 1908. 2 vols.

BALIKCI, ASEN
> *The Netsilik Eskimo.* New York: The Natural History Press. The American Museum of Natural History, 1970.

BIRKET-SMITH, KAJ
> *The Caribou Eskimos: Material and Social Life and their Cultural Position.* Report of the Fifth Thule Expedition 1921-24, Vol. V. Copenhagen: Gyldendalske Boghandel, Nordisk Forlag, 1929.

BLODGETT, JEAN
> "Multiple Human Images in Eskimo Sculpture." Unpublished Master's thesis, University of British Columbia, 1974.
> *Tuu'luq/Anguhadluq.* Exhibition Catalogue. Winnipeg: The Winnipeg Art Gallery, 1976.

> *The Coming and Going of the Shaman: Eskimo Shaminism and Art.* Exhibition Catalogue. Winnipeg: The Winnipeg Art Gallery, 1978.

BOAS, FRANZ
> *The Central Eskimo.* Lincoln: University of Nebraska Press, 1964. (Bureau of American Ethnology, Sixth Annual Report, 1888.)
> *The Eskimo of Baffin Land and Hudson Bay.* American Museum of Natural History, Bulletin XV, 1901-07.

EBER, DOROTHY
> "Eskimo Penny Fashions." *North/Nord,* Volume XX, no. 1 (January-February 1973), pp. 37-39.

ELLIS, HENRY
> *A Voyage to Hudson's Bay by the Dobbs and California in the years 1746 and 1747 for Discovering a North-West Passage.* London: H. Whitridge, 1748.

DRISCOLL, BERNADETTE

"The Inuit Parka: A Preliminary Study based on the collections of The National Museum of Man (Ottawa); The Manitoba Museum of Man and Nature; The American Museum of Natural History; and The National Museum of Natural History, Smithsonian Institution. Unpublished Master's Thesis, Carleton University, in progress.

HATT, GUDMUND

"Arctic Skin Clothing in Eurasia and America: An Ethnographic Study." *Arctic Anthropology,* Volume 5, Number 2, 1969.

HAWKES, ERNEST WILLIAM

The Labrador Eskimo. Canadian Geological Survey, Memoir 91, Anthropological Series No. 14, 1916.

HILDES, DR. J. AND DR. O. SCHAEFER

"Health of Igloolik Eskimos and Changes with Urbanization." *Journal of Human Evolution* 2, 1973, pp. 241-246.

HOLTVED, ERIK

"Contributions to Polar Eskimo Ethnography. Copenhagen: Meddelelser om Grønland, 1967.

HULTON, PAUL AND DAVID BEERS QUINN

The American Drawings of John White, 1577-1590, with Drawings of European and Oriental Subjects. London and Chapel Hill, 1964.

JENNESS, DIAMOND

The Life of the Copper Eskimos. Report of the Canadian Arctic Expedition 1913-1918, Vol. XII, pt. A. 1922.

"Material Culture of the Copper Eskimo" Canadian Arctic Expedition 1913-18, Vol. XVI. Ottawa: King's Printer, 1946.

LYON, GEORGE F.

The Private Journal of Captain G. F. Lyon of H. M. S. Hecla During the Recent Voyage of Discovery under Captain Parry. London: John Murray, 1824.

JOHNSON, CAROL

"The Costume of the Inuit of Hudson's Bay and Igloolik as Depicted by British Explorers in the Late Eighteenth and Early Nineteenth Centuries." Unpublished paper. Carleton University, 1979.

MARSH, WINNIFRED PETCHEY

People of The Willow. Toronto: Oxford University Press, 1976.

MASON, OTIS T.

"Aboriginal Skin Dressing". Smithsonian Institution, U. S. National Museum Report, 1889. Washington, D. C.: 1891. pp. 553-589.

MATHIASSEN, THERKEL

Material Culture of the Iglulik Eskimos. Report of the Fifth Thule Expedition, 1921-24, Vol. VI. Copenhagen, 1928.

MCGHEE, ROBERT

Canadian Arctic Prehistory, Toronto: Van Nostrand Reinhold Ltd., 1978.

MURDOCH, JOHN

Ethnological Results of the Point Barrow Expedition. Bureau of American Ethnology, Ninth Annual Report, 1892.

NELSON, EDWARD WILLIAM

The Eskimo About Bering Strait. Bureau of American Ethnology, Eighteenth Annual Report, 1899.

NEUMANN, ERICH

The Great Mother: An Analysis of the Archetype. Princeton: Princeton University Press, 1955.

ORCHARD, WILLIAM C.

Beads and Beadwork of the American Indians. New York: Museum of the American Indian, Heye Foundation, 1975.

PHARAND, SYLVIE

"Clothing of the Iglulik Inuit". Unpublished Manuscript. Canadian Ethnology Service, National Museum of Man, National Museums of Canada, 1975.

PITSEOLAK

Pitseolak: Pictures Out of My Life, edited from tape-recorded interviews by Dorothy Eber. Montreal: Design Collaborative Books and Oxford University Press, Toronto, 1971.

RASMUSSEN, KNUD

Across Arctic America. New York: G. P. Putnam's Sons, 1933.

Intellectual Culture of the Iglulik Eskimos. Report of the Fifth Thule Expedition 1921-24, Vol. VII, no. 1. Copenhagen: Gyldendalske Boghandel, Nordisk Forlag, 1929.

The Netsilik Eskimos: Social Life and Spiritual Culture. Report of the Fifth Thule Expedition 1921-24, Vol. VIII, no. 1 & 2. Copenhagen: Gyldendalske Boghandel, Nordisk Forlag, 1931.

The Alaskan Eskimos. Report of the Fifth Thule Expedition 1921-24, Vol. X, no. 3. Copenhagen: Gyldendalske Boghandel, Nordisk Forlag, 1929.

ROSS, W. GILLIES

Whaling and Eskimos: Hudson Bay 1860-1915. Ottawa: National Museum of Man Publications in Ethnology, No. 10, 1975.

SALTER, DR. ROBERT B.

"Etiology, Pathogenesis, and Possible Prevention of Congenital Dislocation of the Hips." *Canadian Medical Association Journal,* Volume 98, No. 20, 18th May 1968, pp. 933-945.

SCHAEFER, DR. OTTO AND M. METAYER

"Eskimo Personality and Society — Yesterday and Today." in Proceedings of the Third International Symposium, Yellowknife, N. W. T., *Circumpolar Health,* edited by Roy Shephard and S. Itoh. Toronto: University of Toronto Press, 1976, pp. 469-479.

SCHNEIDER, LUCIEN, O.M.I.

Dictionnaire Esquimau-Français du parler de l'Ungava et Contrées Limitrophes. Québec: Les Presses de l'Université Laval, 1970.

SCHUSTER, CARL

"Joint Marks: A Possible Index of Cultural Contact Between America, Oceania and the Far East." Amsterdam: Uitgave Koninklijk Instituut Voor De Tropen, 1951.

SWINTON, GEORGE

Eskimo Sculpture. Toronto: McClelland and Stewart, 1965.

Sculpture of the Eskimo. Toronto: McClelland and Stewart, 1972.

"Touch and the Real, Contemporary Inuit Aesthetics: Theory, Usage and Relevance," in Greenhalgh, M. and Megaw, V. *Art in Society: Studies in Style, Culture and Aesthetics.* New York: St. Martin's Press, 1978.

TAYLOR, J. GARTH

Netsilik Eskimo Material Culture: The Roald Amundsen Collection from King William Island. Universitet, 1974.

TURNER, LUCIEN M.

Ethnology of the Ungava District. Bureau of American Ethnology, Eleventh Annual Report, 1894.

WILDER, EDNA

Secrets of Eskimo Skin Sewing. Anchorage: Alaska Northwest Publishing Co., 1976.

WILLIAMSON, ROBERT G.

Eskimo Underground: Socio-Cultural Change in the Canadian Central Arctic. Uppsala, 1974.

STAFF CREDITS

The presentation of this exhibition and catalogue has been the result of the creative talent and professional dedication of the following individuals:

FABIOLA BOHEMIER	Secretary, Inuit Department
ELAINE GOLD	Assistant, Inuit Department
DARLENE TOEWS	Designer
EVELYN SEIDA	Typesetter
JANE CHRISTIANI	Head, Public Programs & Education
DAVID ROZNIATOWSKI	Chief Librarian
CAREY ARCHIBALD	Senior Preparator
STEPHEN COLLEY	Preparator
ROBERT CHRISTIANI	Preparator
ROBERT BERKOWSKI	Carpenter
MICHAEL TREVILLION	Matter/Framer
BARRY BRIGGS	Conservation Technician
SHIRLEY ROSCHE	Registrar
STEPHANIE VAN NEST	Registration Assistant
ERNEST MAYER	Head, Photography & A/V Department
MICHAELIN MCDERMOTT	Assistant Photographer
ALLISA MCDONALD	Publications & Sales Co-ordinator
LEIGH SIGURDSON	Public Relations Officer
LAUREN J. WOODHOUSE	Editor

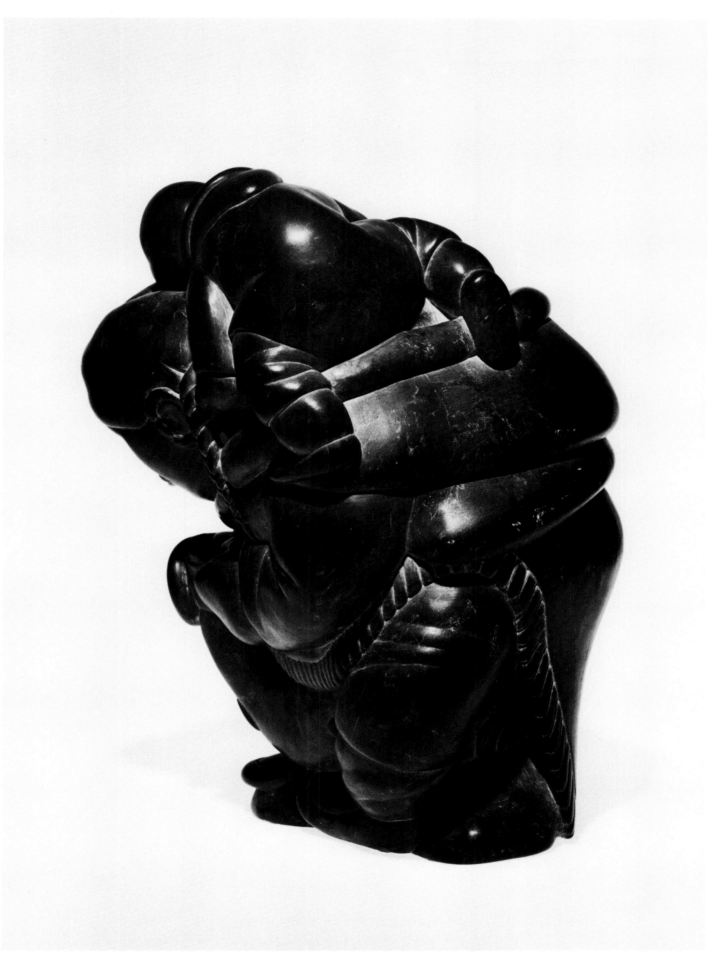

52. Simeonie, *Mother with Two Small Children*, no date.

ISBN 0-88915-085-0

LITHOGRAPHED IN CANADA BY
KROMAR PRINTING LTD
WINNIPEG

COVER

FRONT: 4. Beaded Amautik, 1937
　　　　 The Bishop Marsh Inuit Collection
　　　　 The Manitoba Museum of Man and Nature

BACK: 5. Beaded Amautik, 1971
　　　　 by Marion Tuu'luq
　　　　 Collection of Mr. and Mrs. K. J. Butler,
　　　　 on loan to The Winnipeg Art Gallery

DATE DUE

PRINTED IN U.S.A.